Loosen up your
Watercolours

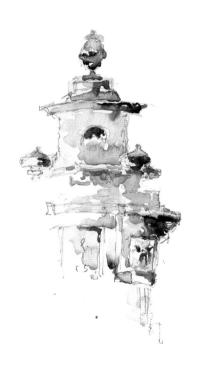

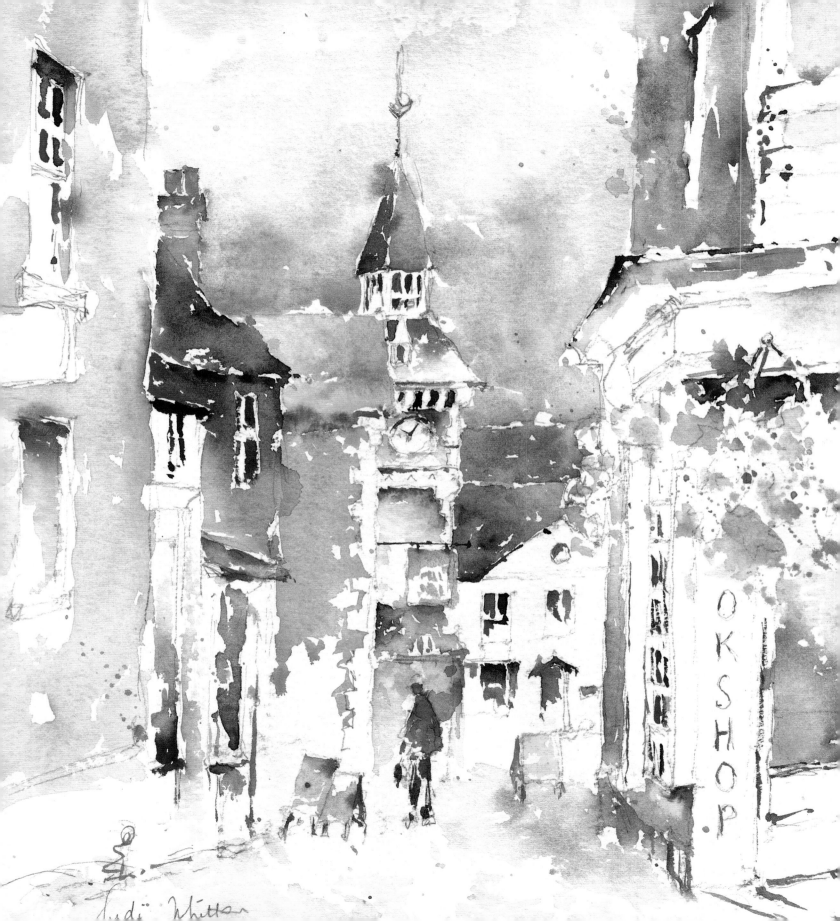

Collins · ARTIST'S STUDIO

Loosen up your Watercolours

Judi Whitton

First published in 2005 by
Collins, an imprint of
HarperCollins*Publishers*
77-85 Fulham Palace Road
Hammersmith, London W6 8JB

The Collins website address is: www.collins.co.uk

Collins is a registered trademark of HarperCollins Publishers Limited.

09 08 07 06 05
6 5 4 3 2 1

A catalogue record for this book is available from the British Library

Editor: Diana Vowles
Designer: Kathryn Gammon
Photographer: Howard Gimber

ISBN 0 00 718324 0

Colour reproduction by Colourscan, Singapore
Printed and bound in Singapore by Imago

Dedication
To the Lewis family

Acknowledgements
It has been a great pleasure to work with Caroline Churton, who has steered this book through its various stages. Thanks too to Howard Gimber for the photography and to Kathryn Gammon and Diana Vowles for their design and editorial skills. I am also very grateful to Cathy Gosling and all the hidden faces at HarperCollins.

I particularly thank John Yardley, John Palmer and Charles Reid for allowing me to include their paintings. They are generous and inspiring teachers. My thanks also go to John Yardley for writing the Foreword.

I am indebted to Sally Bulgin for her support, to Jane Lampard for introducing me to watercolours, and to Sue Wales for her superb still life set-ups.

Most of the paintings in this book have been completed in the valued company of fellow painters Jean Thin, John Lawson, Sarah Edwards, Craig Young, Don Glynn and members of The Palette Club.

Most especially I thank Pete and the girls for all the cups of tea, their interest and support, and magically finding that which the computer had irretrievably devoured.

page 1: Stortorget, Stockholm, 15 × 9 cm (6 × 3½ in)
page 2: Hay-on-Wye, 32 × 24.5 cm (12½ × 9½ in)
pages 4–5: River, St Petersburg, 6.5 × 28 cm (2½ × 11 in)

Contents

6 Foreword *by John Yardley*

8 Introduction

18 Materials

24 Transferring pigment

36 Watercolour methods

50 Tone and colour

62 Picture design

86 Painting vignettes

98 Planned spontaneity

110 Painting outdoors

120 Perennial problems

127 Taking it further

128 Index

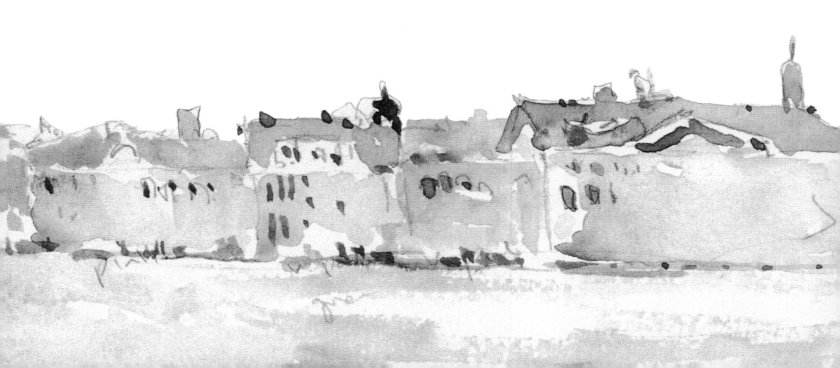

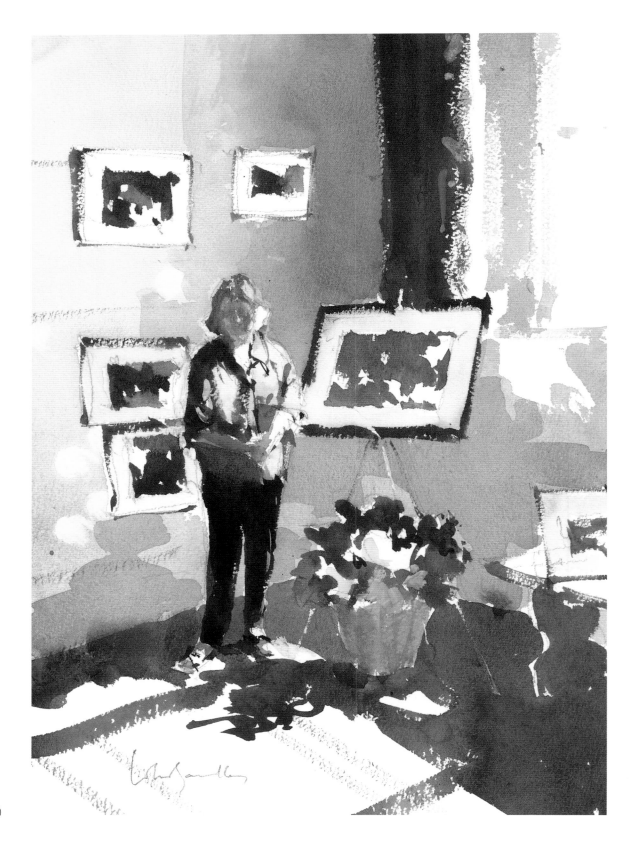

▷ **Judi at Painswick**
John Yardley
35.5 × 25 cm (14 × 10 in)

Foreword

I have known Judi Whitton for almost 15 years now and have seen her painting develop from a fairly traditional style of watercolour into her current lively and vibrant productions. In the way that many Scottish painters are described as 'Colourists', Judi can truly be said to be a watercolourist. Her palette combines depth and subtlety of colour, while the free brushstrokes – almost abstractions – are based on sound drawing ability.

Technical knowledge, composition and great originality are here combined to promote maximum enthusiasm in the student. Admitting to a personal admiration for Judi's work, I can safely recommend this rewarding book not only to those wishing to 'loosen up' but also to those wishing for something different in their painting.

John Yardley

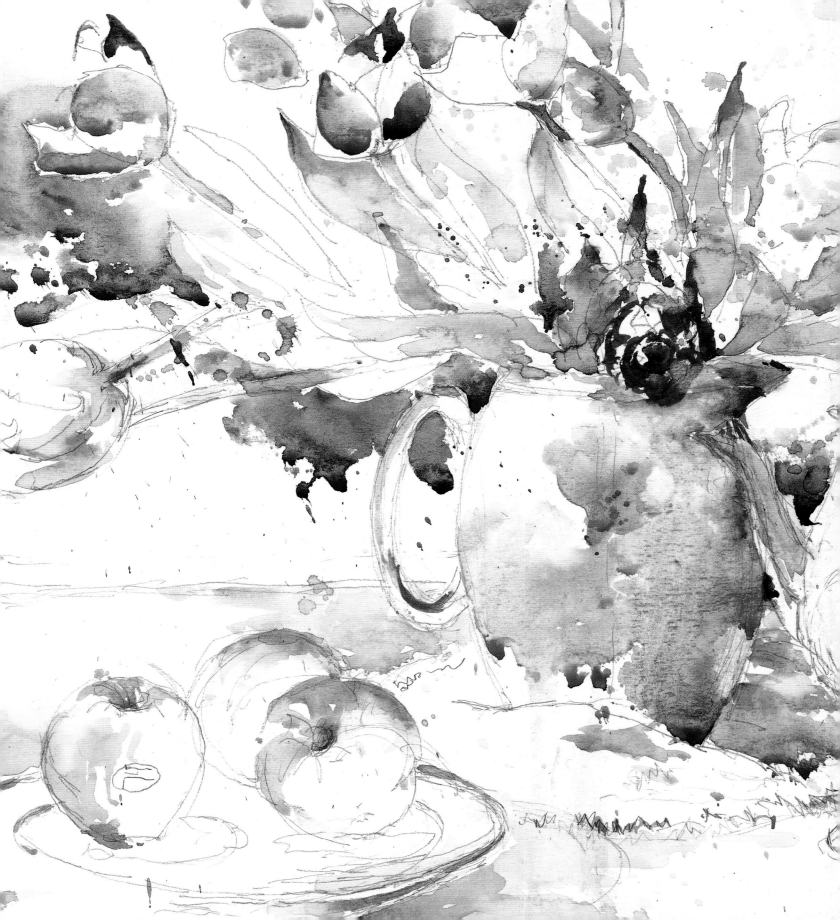

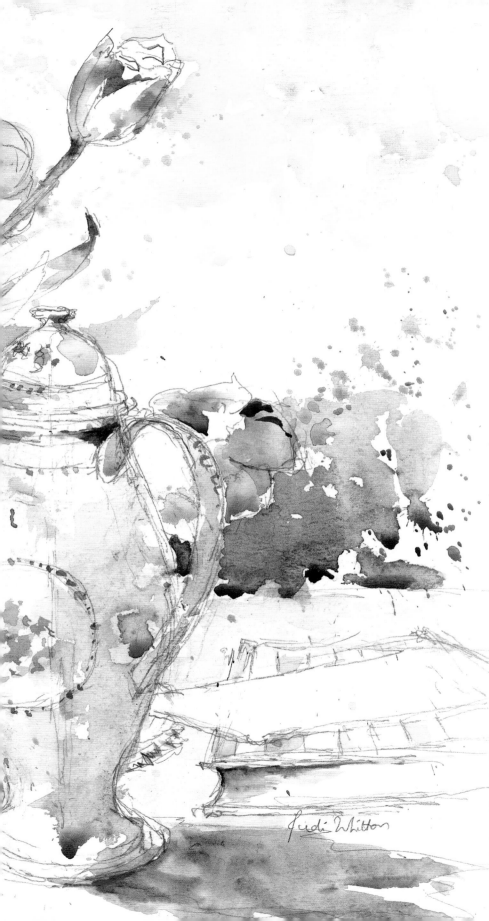

Introduction

It's a funny business being a painter. Certain skills, such as loosening up, sound easy but in practice are difficult to achieve. Many painters yearn to free up their style but often the only advice they can find is, 'Just free up a bit and relax.' Without more specific guidance it is hard to know how to progress, so the aim of this book is to provide solutions for anyone who wants to loosen up their painting – be it a little or a lot – and is at a loss as to how to set about it.

Learning to paint free, seemingly effortless watercolours where the paint appears to dribble off the paper with a carefree simplicity is a straightforward procedure if you tackle it systematically; while watercolour is a bit unpredictable at times, it is nevertheless quite logical. We are all creative, we all have talent and we can all paint more loosely. The ability is in us somewhere and with a little practice, encouragement and guidance it can be found and developed.

◁ Tulips in Blue Jug
40 × 50 cm (15¾ × 19¾ in)

About this book

This book, designed for artists already possessed of a little experience, introduces a methodical approach to loosening up watercolour paintings which is based on the principle that anyone can achieve this and still maintain his or her personal identity. I am delighted to include paintings by John Yardley, Charles Reid and John Palmer as some examples of lovely loose flowing watercolours in styles that are different from my own.

If you have ever wondered how to stop yourself 'filling in' everything, how to keep light and airiness flooding into your pictures, how to decide about the amount of detail to include or how to recognize when your painting is finished, there is help at hand within these pages. You will find guided practical work, Studio Tips and Explore Further sections, together with Food for Thought suggestions where some alternative views are introduced. There are a few surprises, too; for example, producing a spontaneous painting can involve slow and painstaking deliberations. Sometimes it is even necessary to tighten up and analyse your subject before you can reach your aim of loosening up.

The techniques of watercolour painting are more accessible than the philosophy, attitude, perception and style of a watercolour painter. Much of this book is dedicated to the more difficult and even elusive ways of thinking that a loose painter employs, together with ideas to develop your creativity, for these are infinitely more relevant to painting in a loose style than the technical aspects. I hope that within these pages you find plenty to help you to achieve a greater level of freedom, spontaneity and originality in your own individual style of painting.

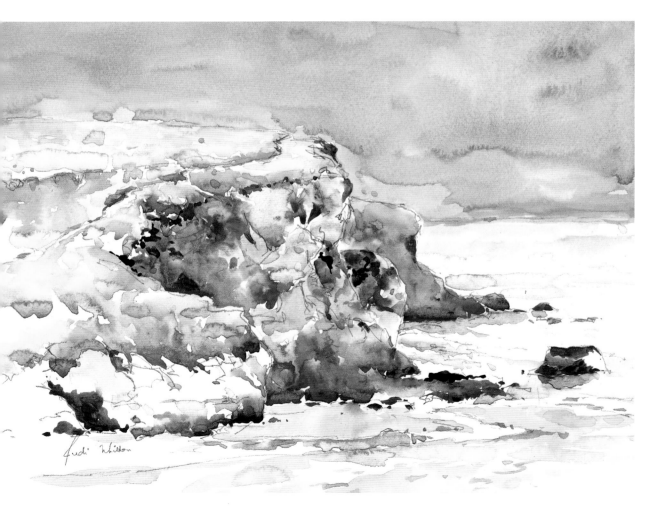

◁ **Rugged Cliffs**
25.5 × 33 cm (10 × 13 in)

This seemingly straightforward subject has been brought to life with the paint-handling techniques and interpretation. The watercolour has been kept simple, while care has been taken to design the shapes within the picture border.

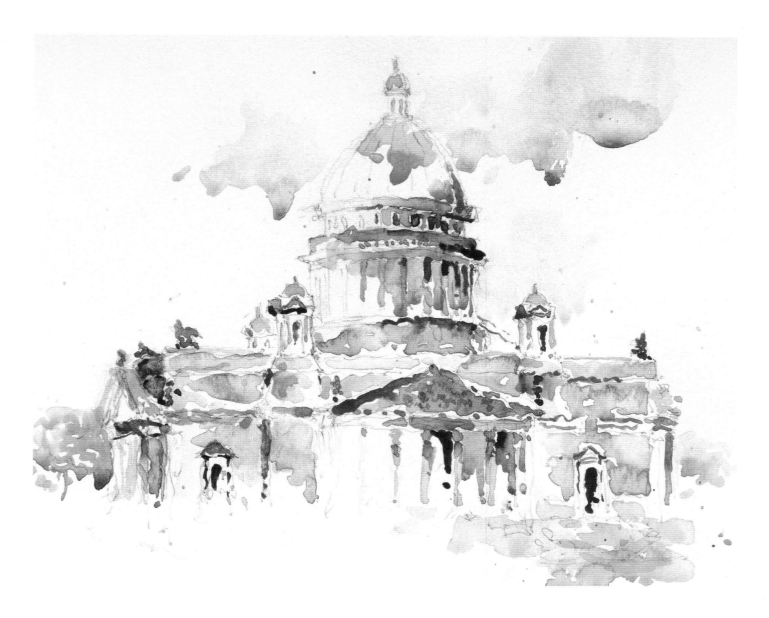

Recognizing your creativity

Sadly, some fledgling artists believe that only special people are creative and that if you aren't born imaginative then there is no hope. This just isn't true. So often we have original ideas but fail to recognize our own creativity.

People sometimes imagine that creativity means rendering the sky purple and buildings orange, but you do not have to go to these extremes to be original. Imagination and creativity are considered intangible and unquantifiable, the preserve of the demonstrably talented; in fact, we all make many creative decisions in our daily lives, such as planning out the garden or deciding where on a table or shelf to place a bowl of flowers.

While many people feel reasonably confident that they can learn painting techniques, given time and practice, they tend to be far more hesitant about their chances of developing their creative abilities. However, there is no elusive magic to the imaginative side of art; it is just a matter of recognizing that you use the creative side of your brain whenever you paint. An artist can develop by means of creative exercises in the same way that practising technical matters will lead to greater skill.

△ St Isaac's Cathedral, St Petersburg
18 × 23 cm (7 × 9 in)

With just 20 minutes available, I felt hopelessly inadequate trying to capture this magnificent building in my sketchbook. However, looking at my attempt now, every one of those precious minutes is imprinted in my painting memory.

△ Hotel Bristol, Oslo
25.5 × 20 cm (10 × 8 in)

This watercolour was completed in my journal as we sat in the bar. The painting illustrates a free approach to an interior subject and a loose handling of the paint.

Painting loosely

Painting loosely is a very general term and encompasses a multitude of different aspects of painting. It does not mean just painting fast, being inaccurate, not including detail or painting carelessly; instead, it describes a free approach to placing the paint on the paper which leads to a sense of spontaneity in the finished work and avoids unnecessary fussiness in paint handling. It is about free brushstrokes, an open approach, minimum paint handling on the paper, unfussy interpretation and, above all, 'thinking' loosely. Indeed, Charles Reid says that 'loosening up' is a 'state of the mind' not a 'state of the brush'.

It is a sad fact that a very carefully and accurately painted watercolour can sometimes result in a stiff and static painting. The more effort you make may only result in further lifelessness. Achieving a loose style can be learnt and then you can direct your effort instead towards creating loose and spontaneous paintings.

Freeing up

Freeing up is about an attitude of mind and involves a gain in confidence which comes with practice and learning how to achieve the result you want. As you grow as an artist you will become braver and more skilled about what to include and what to leave out and more courageous about declaring your picture finished at exactly the right stage. This confidence will also show itself in the assured marks that you make on the paper and enable you to express liveliness in your paint-handling skills.

In general, the more accomplished students become, the greater their fascination for rendering watercolours with simple brushstrokes and spontaneous washes. The longer you look at your subject and begin to know it and understand it the easier it becomes to paint it with freedom. For this you may find it encouraging to practise loosening up your work while painting familiar subjects.

The following few pages provide a brief overview of various issues surrounding painting with freedom and spontaneity, together with an introduction to some topics covered in this book.

The right amount of detail

Matisse said, 'What I am after, above all, is expression . . . The entire arrangement of my picture is expressive; the place occupied by the figures, the empty spaces around them, the proportions, everything has its share . . . A work of art is harmonious in its entirety; any superfluous detail would replace some other essential detail in the mind of the spectator.'

It is this superfluous detail that is the enemy of the loose painter; when you are painting it is so easy to add another brick on the wall or another petal on the daisy. You need to keep reminding yourself that your viewer will know that it is a brick wall when you have hinted at just two brick shapes (or possibly even one).

Remember Matisse's words. Keep telling yourself that unnecessary detail destroys the impact of your painting and dilutes the impression you wish to convey. In general, you will need less detail than you think for your viewer to understand what is going on in your painting.

While you are painting, ask yourself constantly, 'Have I said too much?' 'Have I said enough?' After you have finished this book you should be able to make a friend of the essential detail and discard unnecessary information without a backwards glance.

▽ Newquay Harbour, Cornwall
24 × 30 cm (9½ × 12 in)

From a busy scene, I selected two boats at the harbour wall and concentrated on which of the observed details were important to include and which could be omitted.

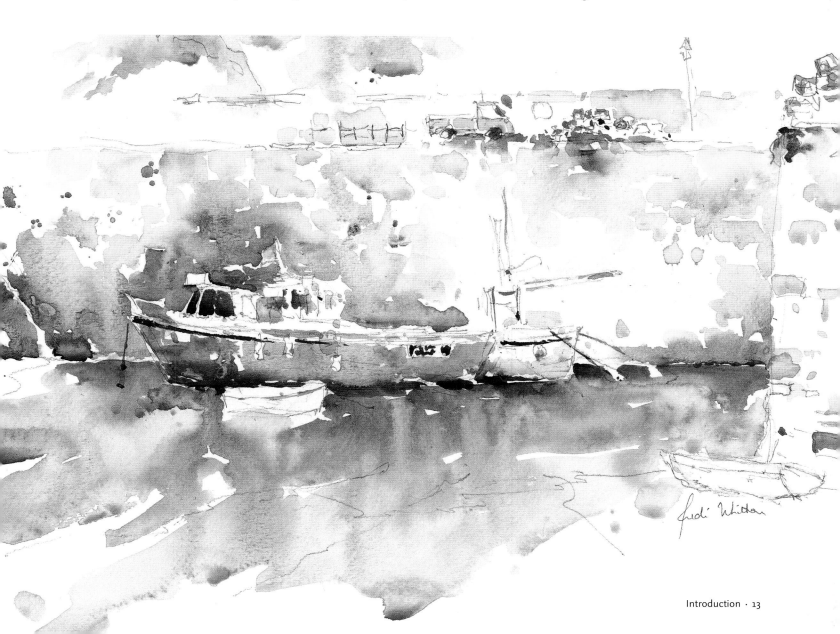

Handling paint in a lively manner

It is sheer delight to watch an accomplished loose painter handling the brush and paint with confidence and delivering exquisite free marks to the paper. It can look so effortless, but when you try to do it yourself too quickly it can turn into a disaster.

Much depends on looking at your subject and understanding it. If you are very familiar with how a tree is formed you can render it simply, economically and with lively brushstrokes. This will bring your pictures to life and give your work a sense of immediacy and spontaneity.

In this book you will find encouragement to maintain a feeling of vigour and life in your work right from the initial drawing to the final stages, when it is all too easy to begin to tighten up, perhaps when adding a figure.

◁ **Hydrangea Lacecap**
17 × 17 cm (6¾ × 6¾ in)

This sensitive painting shows a lively but carefully considered approach to painting flowers.

▽ **Painting in the Garden**
35.5 × 51 cm (14 × 20 in)

The paint is applied in a lively manner throughout this *plein air* watercolour, thus giving an air of spontaneity. In fact the painting took several hours to complete and parts were quite painstaking in execution.

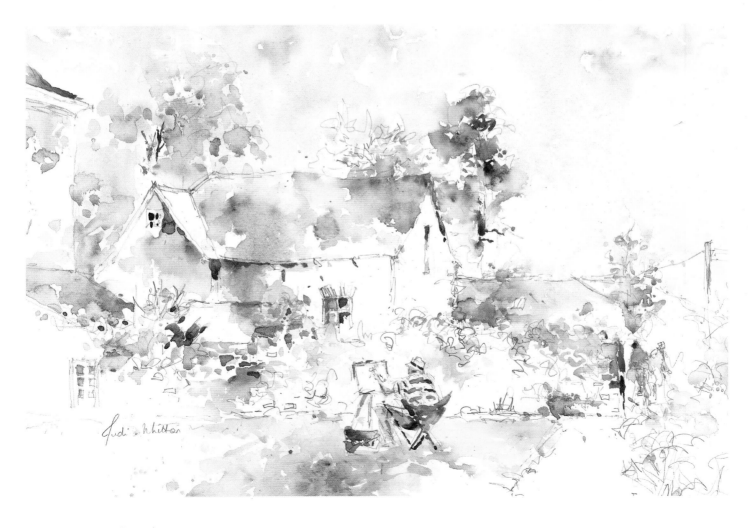

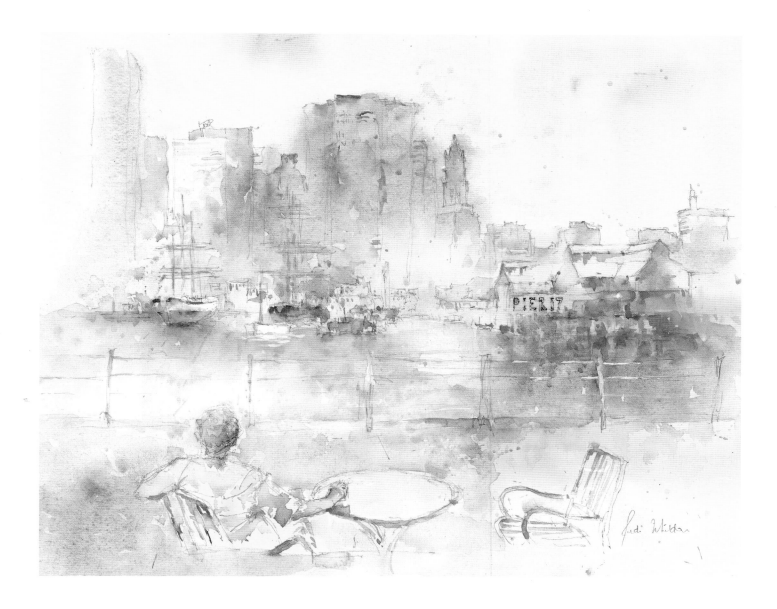

Simplification

It may seem surprising, but the more you try to paint your subject exactly as you see it the less interesting your painting becomes. It is so important to render the components of your picture as simply as you can. Only in this way will the painting as a whole have the impact you would wish.

John Yardley describes painting loosely as being deliberately rapid execution allied to simplification of subject matter – but adds the warning that you should not be tempted to speed up until you have the basics under control.

The human eye takes in so much detail that considerable discipline is required to learn to ignore some elements of the subject in order to draw attention to the selected parts. Just what you should leave out cannot be dictated by another artist's opinion; it is a matter of choice.

Selecting parts of your subject and simplifying detail both involve an individual interpretation of the scene and so the personal vision of the artist shines through. Throughout this book there are suggestions as to how to make choices about simplifying the world you see and decide the balance of distinct and indistinct parts in your work.

△ **Looking across the East River to Pier 17 and the New York Skyline**
33 × 41 cm (13 × 16 in)

There was interest in the foreground (the figure at the table), the middle distance (sailing vessels and Pier 17) and far distance (the skyline) of this view. Everything was simplified in the painting, but the dominating skyline was given most brevity in order to give impact to the overall scene.

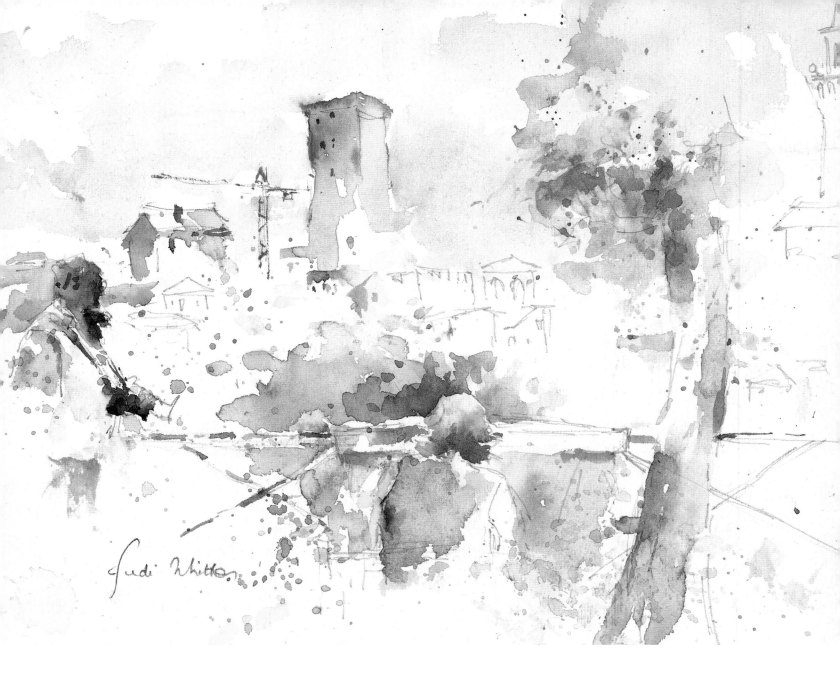

Deciding what to include

Matisse's advice that superfluous detail detracts from essential detail may have made you wonder how to distinguish between them. In fact the only person who can do this is the artist; it is these choices that give your individual stamp to your work. What drew you to your subject in the first place is the key to your success, together with holding onto your initial impression throughout the painting process and not becoming bogged down by irrelevant parts.

A large part of becoming a loose painter relies upon building confidence, since gaining the confidence to leave things out is just as important as acquiring the technical abilities necessary to paint things in. This book addresses many of the decisions there are to be made about what to include and exclude. Plenty of photographs, which were taken alongside my *plein air* painting sessions, are reproduced here so you can see my particular interpretations. This will encourage you to make bold decisions about your own work.

△ **Painting in Sienna**
23 × 28 cm (9 × 11 in)

This picture shows a friend immersed in her painting in Sienna, watched by a tourist. The viewer is invited to look at the focal areas: the view, the painter, the onlooker and the tree. The bush provides linkage from the painter to the distant parts of the scene and there is no filling in of irrelevant information.

Knowing when to stop

The degree of 'finish' you like in your watercolours can only be decided by you. A loose watercolour with spontaneity and immediacy can be spoilt if it is overfinished. How often did you prefer your watercolour at an earlier stage than the one you ended up with? With experience and guidance you can develop your finishing skills and learn to judge when your picture is at its maximum potential.

Picasso deplored the idea of 'finished' work. He expressed his view like this: 'To finish a work? To finish a picture? What nonsense! To finish it means to be through with it, to kill it, to rid it of its soul, to give the *coup de grace* for the painter as well as for the picture.'

▽ Main Square, Sienna
22 × 24 cm (8½ × 9½ in)

A fellow artist asked me why I had stopped work on this watercolour. He was used to a more completed look in his own watercolours, but I was happy with my decision that it was finished.

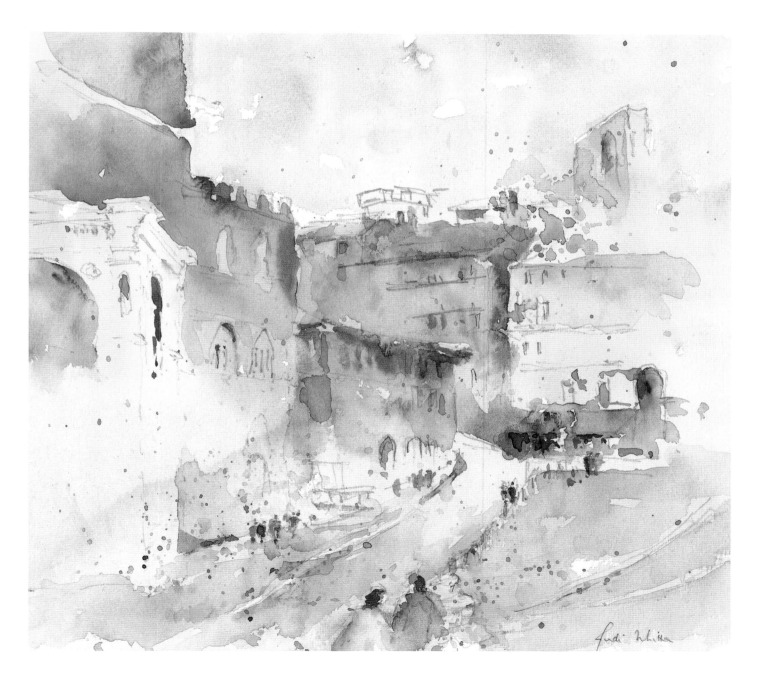

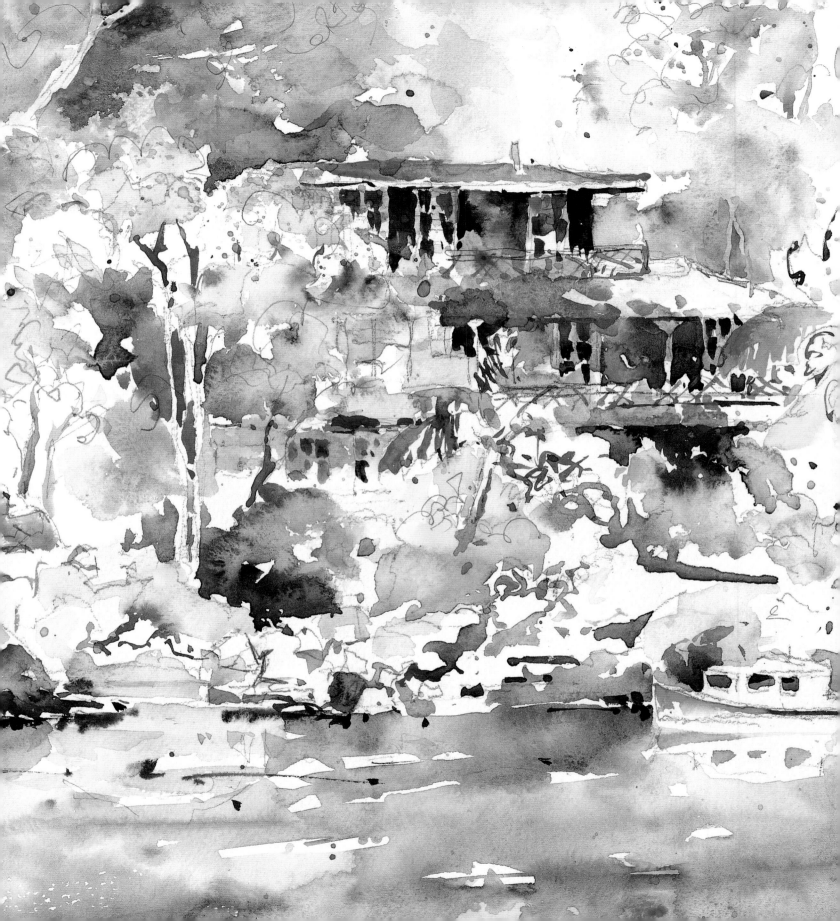

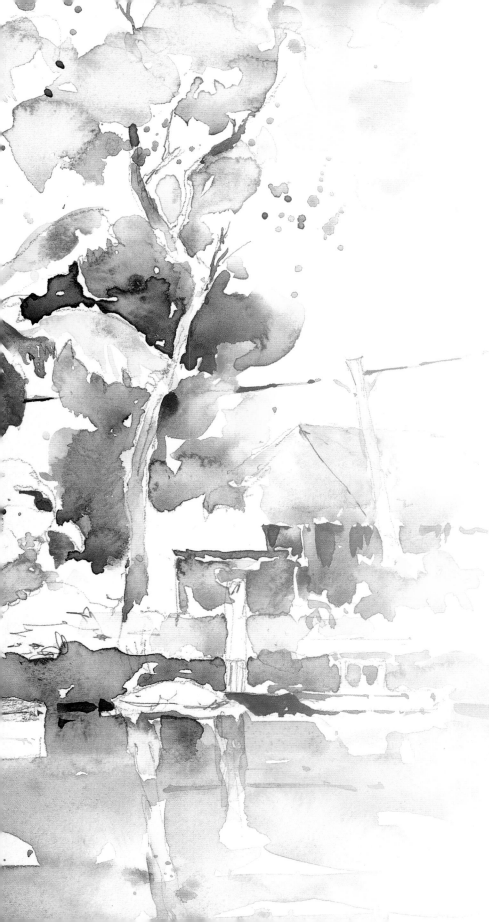

Materials

The most useful advice on art materials is, 'Keep it simple.' You have so many decisions to make when you are painting that it is very important to reduce to a minimum the choices about which brush and which pigment to use. There are many exciting materials available for the artist and it is easy to be seduced by wonderful advertisements for art products which promise success in the finished paintings. Unfortunately, the outcome you want can't be guaranteed by the expenditure you make!

In order to keep this chapter brief I have merely summarized the art materials I have found very useful over the years. It is vital for you to be familiar with your own equipment and know how it works best for you.

◁ Hawksbury River, Australia
40 × 50 cm (15³/₄ × 19¹/₂ in)

Choosing your equipment

What a treat it is to purchase a new item to add to your collection of art materials. Then, without realizing it, you may often find you have returned to your familiar comfort zone and the new item is tucked away in a drawer. After years of experimentation I have settled down now to a very basic collection of reliable materials – though I do still enjoy trying out new pigments and paper from time to time.

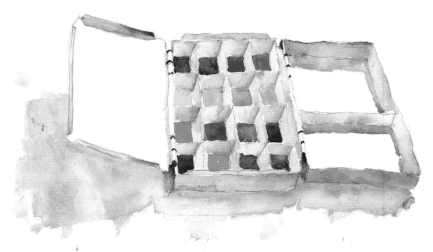

Paints

I generally prefer to use artist's quality tubes. However, pans of paint rather than tubes are useful when you are travelling.

I hesitate to suggest a range of pigments to form the basis of your palette as there are so many wonderful colours to choose from. However, here is a list of the pigments that are to be found in my little paint box today: Coeruleum, Cobalt Blue, Prussian Blue, French Ultramarine, Naples Yellow, Yellow Ochre, Cadmium Yellow, Lemon Yellow, Burnt Umber, Burnt Sienna, Alizarin Crimson, Cadmium Red, Oxide of Chromium Green, Viridian, Cadmium Orange and Permanent Mauve.

Laying out your palette

There are no hard and fast rules about how you lay out your palette. The only essential thing is to be consistent so that you are familiar with the position of each colour and do not have your concentration broken by having to search for a particular pigment while you are painting – but do try different pigments occasionally.

My own box is laid out with the blues, yellows and reds together and some extra favourites such as Cadmium Orange in the fourth column.

△ Here you can see the 16 colours that I use, in compartments which are suitable for half pans or paint squeezed from tubes.

▽ My painting kit includes a brass brush holder and Sketcher's Box which are lightweight and rust-proof.

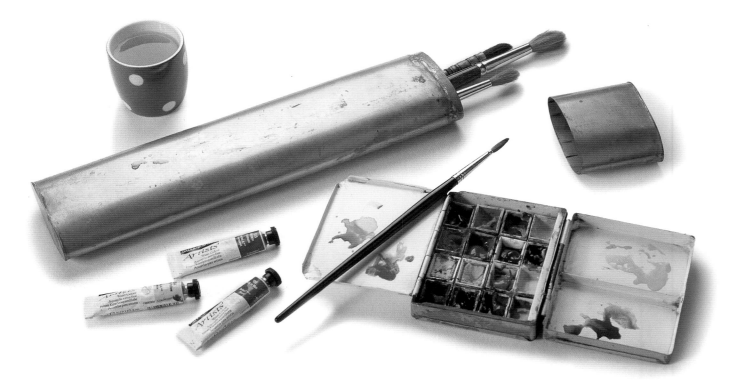

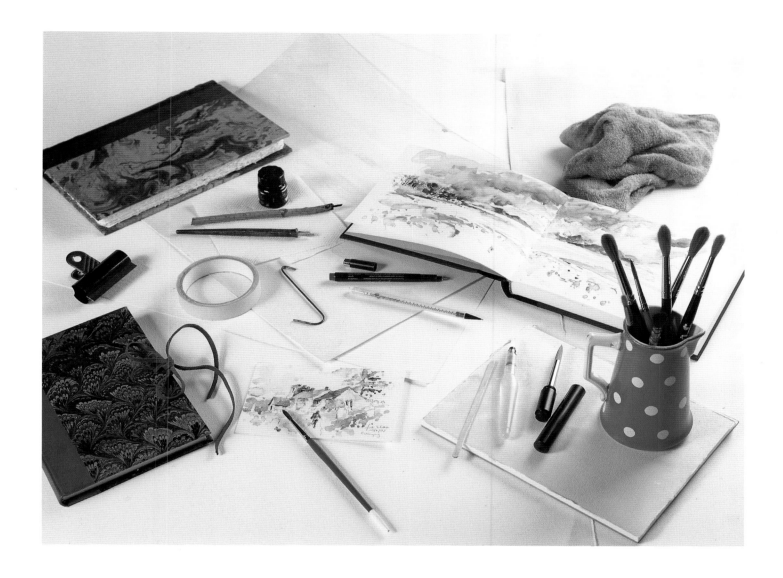

Other items of equipment

A disposable propelling pencil with a little eraser at the end provides a reliable and convenient method for drawing and erasing without any fuss. Somehow this type of pencil dances across the watercolour paper and I find the resulting marks ideal in the finished work.

My preferred 15 × 20 cm (6 × 8 in) sketchbook is suitable for paint and opens out for panoramic subjects. If I am travelling I may just take a watercolour journal of about 28 × 33 cm (11 × 13 in).

As for brushes, sizes 11, 9 and 6 in a straightforward round watercolour brush will suffice. Sable are the best but a mixture of sable and artificial fibre is good value for money. Sometimes a squirrel mop brush size 0 is useful for making very free marks. Always try to use a large brush if you can.

At present I mainly use a Not paper of 300 gsm (140 lb) weight, which I do not stretch. Watercolour paper presented in block form is very practical, especially when you are working outside. However, if you work very wet it may be better to stretch sheets of paper and secure them to a board. There are some exciting tinted and textured papers available now which replicate those used by some of the old masters.

My big luxury, which I use all the time, is a very simple little handmade brass paint box called the Sketcher's Box. It measures 6.5 × 9 cm (2½ × 3½ in) when closed and has 16 compartments.

△ Among this selection of useful painting equipment can be seen one of my disposable propelling pencils and a retractable sable brush size 10, which is invaluable on painting trips.

Staying in to paint

Painting by a window in natural light is most authentic, but if you need to use an artificial light source it is worth investing in a daylight bulb which gives a similar colour temperature. For a still life set up it can be interesting to have daylight illuminating one side and an artificial light source with a conventional bulb on the opposing side. Observations of the differing effects produced by the cool and warm sources of light will provide an interesting and inspiring painting session.

Assemble a collection of prints of work by some of your favourite painters. Have them pinned up in front of you, but rather than copying them strive to put into your own work the inspiration you found in their interpretation of the world.

Don't underestimate the importance of things to make you happy and relaxed. For me my music is very important, as is the companionship of my whippet Barnaby curled up under the easel. Make room for friends to come and paint with you, as much of an artist's life can be a bit lonely – but be selfish about discouraging interruptions.

You may wish to allocate a tiny space in your studio for your computer. It is invaluable for adjusting images and downloading information, and communication by email is far less disruptive than the telephone when you are painting.

Whether you prefer to sit or stand or whether you paint in a studio or on the kitchen table, all the other issues are up to you. Make yourself comfortable and you'll wonder where the day went!

Studio tips

• When you are working in the studio in a comfortable and controlled atmosphere, setting yourself personal challenges can enhance your concentration. For example, try restricting your palette to three colours or completing the painting in a limited time.

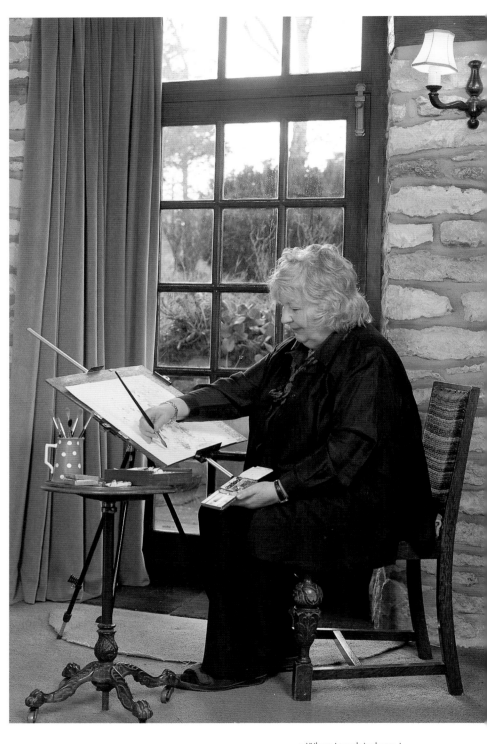

△ When I work indoors I settle in different parts of the house throughout the day to take advantage of the changing light.

Painting on location

Most of the paintings in this book were completed outside. As an enthusiastic *plein air* painter I have devoted the whole of Chapter 8 to the issues that surround working on location. This page is concerned merely with the practical aspects of getting organized for a trip.

From experience, I advise that your own personal comfort should take priority over some detail of painting equipment. It may sound unsophisticated, but thermal underwear, boots with two pairs of woolly socks, scarf, hat and fingerless gloves are a painter's friends – not to mention a waistcoat with plenty of big pockets and a windproof jacket with a hood which doesn't constrict movement too much. At the other extreme, a sunhat and midge repellent may make the difference between a good day and a miserable one.

It is important not to have the sun directly on the paper, so stand in the shade or turn or tilt the board. Wearing sunglasses makes decisions about tone and colour difficult, so a hat with a brim is a better choice. A white painting umbrella is invaluable for providing shade and useful if it rains.

All my on-location equipment (plenty of water, thermos, camera, sketchbook, paints, brushes and palette) goes in a rucksack. The umbrella and easel fit in an easel bag which goes over the shoulder, leaving my hands free for my lightweight chair and painting block.

When I am snatching an odd moment *en plein air* I take the bare essentials in a little bag together with my journal, retractable brushes and a piece of bubble wrap to sit on. If space is at a premium you can now even buy brushes with a water reservoir in the handle.

Plenty of unexpected things happen when you are painting outside, so be prepared to improvise when things go wrong. (Though you will not forget your water more than once!) Any way of transferring pigment to paper is acceptable in times of hardship.

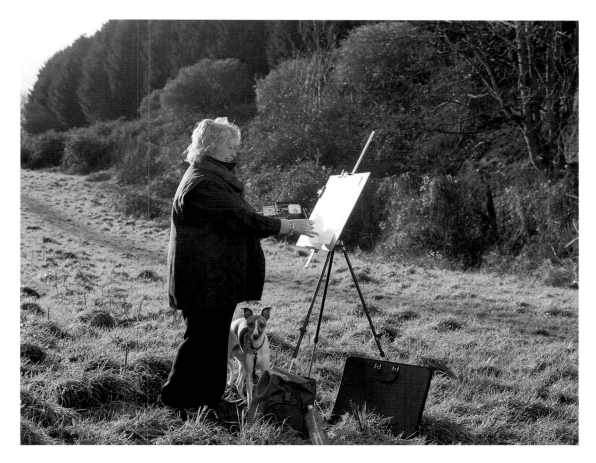

◁ Outdoors in winter, I just wrap up well. Half an hour on location is worth several hours in the studio.

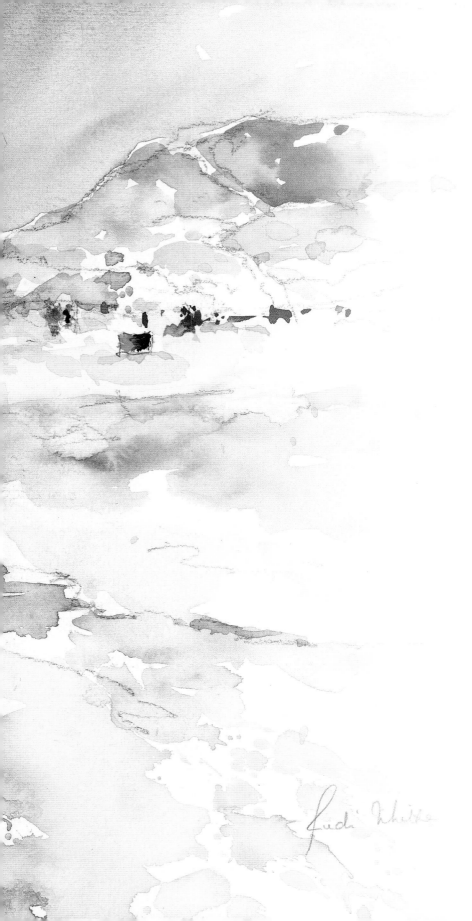

Transferring pigment

Painting is a very 'thinking' occupation and after you have mastered a few basic techniques there are many decisions to make about the look of your finished work and how you are going to arrive at that. A number of factors come into play, such as the angle of the board and the choice of brush, paint and paper to achieve the effect you want.

An artist who produces attractive work of quality may be described as 'having a nice touch'. Ways to achieve this are also covered in this chapter, in particular the balance of water and pigment on the brush and your individual brush handling skills when you transfer pigment from the palette and touch it on the paper. This is a very personal thing, and you can adapt your style at any point you feel ready to explore further.

◁ The Orange Windbreak, Perranporth
30 × 45 cm (11 × 18 in)

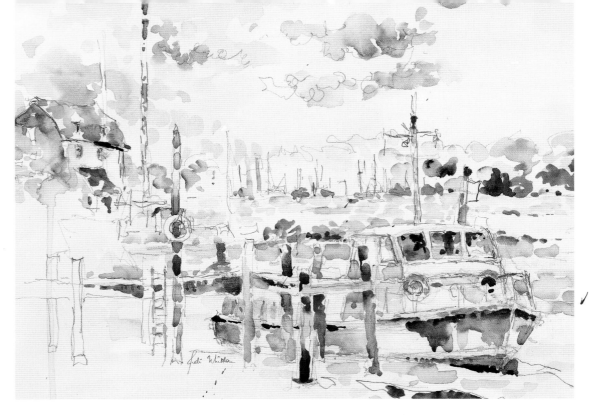

In this on-location watercolour strong pigments have been placed on the paper in little blobs. In places another small puddle of a different colour has been placed adjoining the first so the pigments have merged together on the paper. The way the pigments have settled, and consequently the overall look of the finished watercolour, depends heavily on the fact that the board was in a nearly upright position.

Using your equipment

It is important to be familiar and comfortable with your equipment. Experiment with the way you use your materials until you feel you are working with the maximum concentration on your watercolour painting and are not distracted by an awkward arrangement of your kit.

The angle of your board

The angle of the board holding the paper is crucial to the finished look of the work. There is no 'right' or 'wrong' angle but it is important to discover how different degrees of tilt can affect the outcome.

If your painting surface is flat the water will sit on the surface in puddles. This is not necessarily a bad thing, unless there is so much water that the painting surface cockles and the puddles settle into these undulations. Granulation is exaggerated too, but many artists do feel happy working in this way. However, your image will be less distorted with the paper angled at an upright position rather than absolutely flat.

If the paper is at an angle of about 20 degrees, some of the above problems are reduced and you still have quite a good degree of control over your washes. At an angle of 45 degrees problems begin to arise, since the washes can flow down the paper. There is compensation though, for at this angle (preferred by Angus Rands) a lovely bloom, like that on a rose petal, can be seen in the washes when they have dried. The way the pigments settle on the paper and the evaporation of the water off the surface affect the look of the work in a very exciting way.

As your paper surface becomes steeper you will have more problems with the washes running in dribbles down the paper surface. Despite this difficulty I prefer to work with the paper fairly upright as the paint dries with exciting results.

Explore further

- Try painting with the board at different angles, increasing the steepness until it is nearly upright.
- If you feel you are losing control and the washes run down the paper, reduce the amount of water in the brush. It is important however to keep sufficient wetness to allow the washes to settle on the paper and for a little puddle of water to collect along the bottom edge of a wash.

Handling the brush

It is essential that you develop an effective way of transferring pigment to paper to produce the look you want. If you get to grips with the procedures on this page it will have more effect on your work than the ideas on any other page of this book. You cannot be a good loose painter if your paint handling is erratic.

If you hold the brush like a pencil with your fingers near the metal sheath and rest the side of your hand on the paper you will be able to be very precise in your brushstrokes. However, this degree of control is limiting if you wish to make free, expressive marks.

Holding the brush further down the handle and flexing the wrist when you apply the paint will encourage you to be loose. You can allow your little finger to touch the paper occasionally when you need extra stability.

Loading and delivering the paint

It is essential to have moist paint always in the palette or you will be unable to transfer the necessary amount of pigment to the brush. Wet the brush thoroughly and shake it onto the ground to disperse excess water. Touch the brush into the palette and transfer a splodge of neat pigment to the paper. Wash the brush and repeat, using a different colour and placing the new blob next to the first so that they run together on the paper. Don't interfere – allow the paint to mix on its own.

If the colours don't merge you may need to slightly increase the amount of water. If they flood together, reduce the water on the brush and increase the pigment.

When you deliver the paint to the paper, it is very important to vary the direction of the brush handle and the angle to the paper. I frequently hold the brush vertically with the bristles downwards. Don't limit yourself to the tip of the brush – be prepared to press the brush down onto the paper if that mark is required.

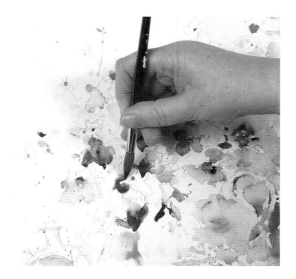

◁ Placing the first colour: keeping the board at a fairly steep angle, I transferred Cobalt Blue straight from the pan to the paper with a damp brush. I held the brush with the bristles pointing downwards as I created the petal.

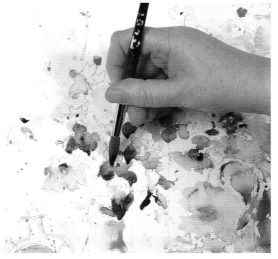

◁ Placing the second colour: after washing and shaking the brush I transferred Alizarin Crimson straight from the pan to the paper. I formed a new petal, allowing the pink wash to touch one short edge of the wet patch of blue and lifting the brush immediately so the colours intermingled unaided.

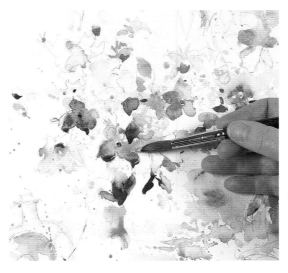

◁ Painting the background: with a clean brush, I transferred a weaker wash of Coeruleum from the pan to the paper and linked the background to the pink petal. I left the puddles of pigment and water to dry without interference.

Applying paint directly

On the previous page the idea of mixing the paint on the paper was introduced. You may be wondering why this is desirable when it is clearly easier to control the pigments when they are combined on the palette. The importance of paint mixing methods is best illustrated by comparing two sets of paintings done in different ways.

Mixing on the palette

The advantage of mixing the paint on the palette is the added control over the hue and tone of the required colour. The disadvantage is that a look of freshness in the work is lost and there can be a sense of monotony.

When you have mixed the paint on the palette you can use the strokes of the brush to describe the form of the subject, which enables you to define shape and contour more easily. However, when shapes are described entirely by brushstrokes there can be a feeling of predictability.

Since painting the dancers on this page I have developed a different style. A comparison with my current technique, shown opposite, illustrates the different principles involved and the resulting change in the look of my watercolours.

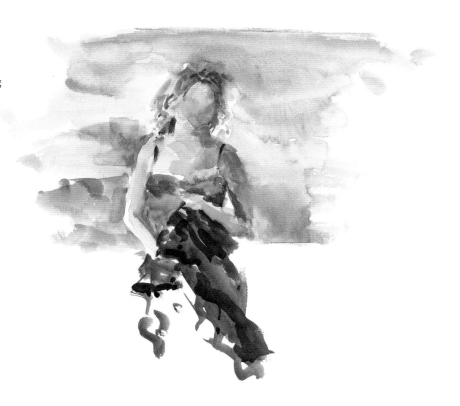

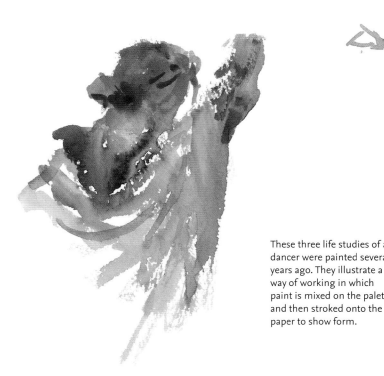

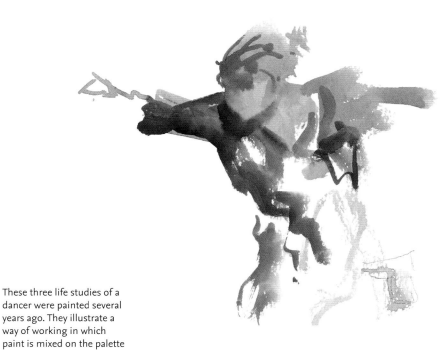

These three life studies of a dancer were painted several years ago. They illustrate a way of working in which paint is mixed on the palette and then stroked onto the paper to show form.

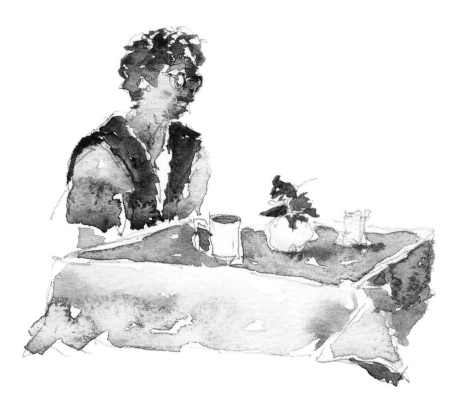

Explore further

- With a potted plant for reference, draw several leaves on a sheet of watercolour paper.
- Place patches of yellow paint where you see yellowy green on the leaves and adjacent patches of blue where you observe bluer green areas. Allow them to mingle on the paper and dry without interference.
- For some leaf shapes gently tease the paint outwards while it is still wet to show the form and for others just allow the pencil line to show the leaf shape. Compare the results.

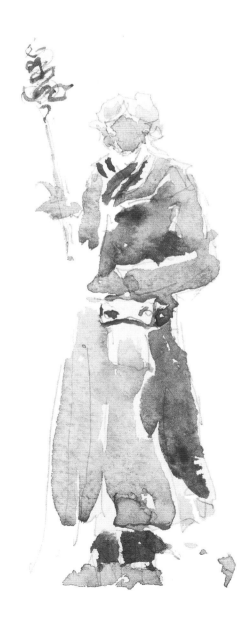

The two direct-observation sketches here were painted more recently than those on page 28 and show a change in approach. The pigments were mixed on the paper and patches of colour rather than brushstrokes describe the form.

Mixing on paper

When you mix pigments on the paper by placing shapes of colour side by side and allowing them to intermingle without intervention, the paint dries with a clarity of colour that is very difficult to achieve when the pigments are mixed on the palette.

The disadvantage of using this method is that it is a rather hit and miss procedure. With practise you will gain some control, but, depending upon your temperament, you may find a degree of unpredictability exciting.

Placing patches of colour

By placing areas of colour on your paper and not using strokes to define shape you are relinquishing some degree of realistic representation. However, the viewer does not require every 'i' dotted and every 't' crossed in order to understand what is going on in a painting. Often you will be more concerned with conveying a mood and atmosphere rather than achieving photorealism, so these areas of colour may speak volumes to your viewer and you need not be over-fussy about details.

Splashing and spattering

The great advantage of splashing or spattering paint is that it arrives on the paper without the brush having the opportunity to stir up pigment particles, thus muddying the work. Pigments delivered into a wet wash produce exciting unsullied effects, while the unpredictability of just how they will appear on the paper gives spontaneity. This is invaluable for freeing you up if your painting has become tight and finicky.

Splashing and spattering can be employed to give texture to part of the finished watercolour. This is useful if, for example, you have a pebble beach or foreground stones which need some type of random finish. These techniques can also lend emphasis to a certain area of a painting. You can achieve a directional effect to lead the eye into the picture by sweeping the brush across the work while it delivers the paint.

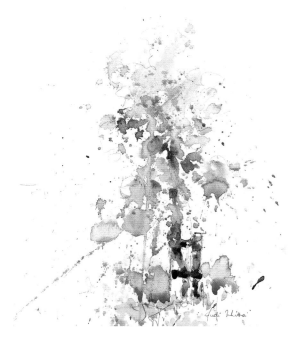

◁ In this small study Coeruleum, Naples Yellow, Raw Sienna, Prussian Blue and Cadmium Lemon were splashed into the foliage area and allowed to mix on the paper. The delivery of pigment in this manner resulted in a fresh and spontaneous effect.

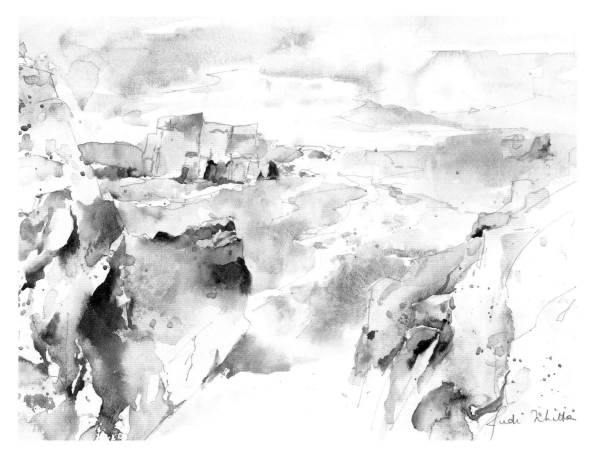

◁ Cornish Coast
24 × 32 cm (9½ × 12½ in)

In this watercolour a limited amount of splashed paint draws your eye to particular areas and gives them emphasis. The subtle mid-tone washes were applied when the underlying paint had dried.

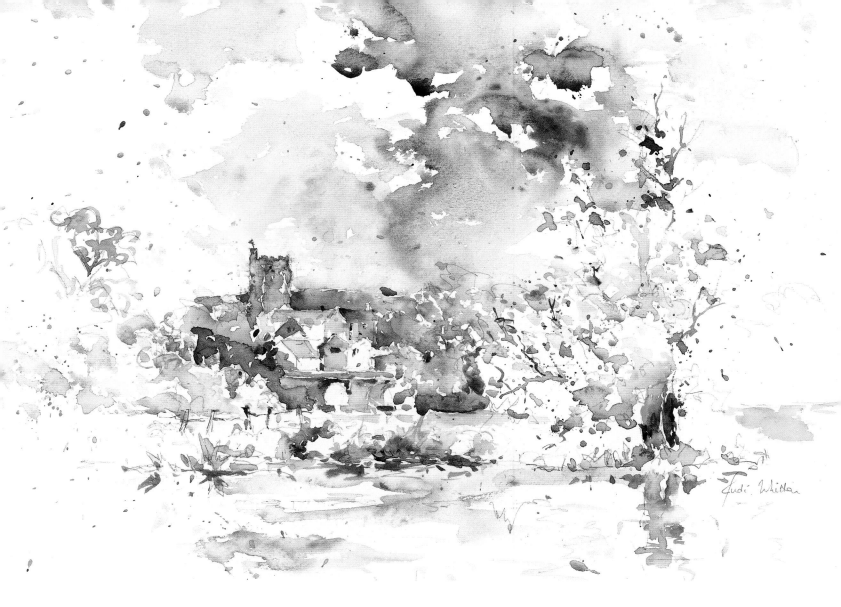

△ **Across the River Usk to Brecon**
33 × 38 cm (13 × 15 in)

In order to keep loose and to introduce some vigour and liveliness into this on-location watercolour, I splashed paint throughout the entire painting process but in particular during the painting of the tree area.

How to splash and spatter

To splash, load the brush with pigment and plenty of water. Hold it over the paper and, with the other hand, tap the brush smartly on the metal sheath just above the bristles. Alternatively, you can tap down the index finger of the hand holding the brush. This takes a bit more practice and is difficult if you are using a mop brush. If your splashes go where you don't want them, you can quickly mop them up with a tissue. With practice you will be able to develop quite a degree of control.

To spatter, load an old toothbrush with pigment and pull the handle of your brush across it to deliver a fine spray of pigment to the paper. If you wish to splash or spatter over a limited area, mask off other parts of your painting with scrap paper.

Studio tips

• By practising on scraps of paper you will quickly learn the amount of wetness required in the brush to deliver splashed paint. Try to master tapping the brush with the index finger as this allows the splashed paint to be delivered with the minimum of interruption to your painting flow.

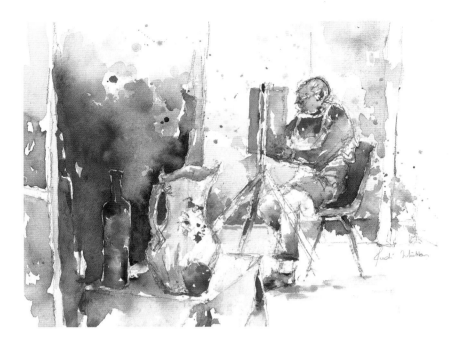

Retaining translucency

Some pigments, for example Aureolin, Phthalo Blue and Viridian, are transparent while others, including Cadmium Red, Naples Yellow and Coeruleum, are relatively opaque. Manufacturers' charts will give you information to guide you on this. However, your choice of transparent or opaque pigments has less relevance to producing flowing translucent watercolours than your paint-handling techniques.

It is still quite possible to produce a muddied piece of work even if all your pigments are transparent. This can arise if you handle the paint carelessly and overwork the pigments on the paper. On the other hand you can produce a beautiful, transparent, free watercolour which incorporates many opaque pigments if you place the paint on the paper (rather than stroke it on) and do not interfere with it as it dries.

△ **Harry Bell at Thornbury Art Club**
19 × 26 cm (7½ × 10 in)

It is painful for me to include this painting as an example of over-muddied work. The large area on the left, which is the backcloth for the still-life set-up, was too pale in my original effort. I 'corrected' it later by overpainting with a darker tone and managed to stir up the pigment underneath, thus losing all sense of translucency in this area.

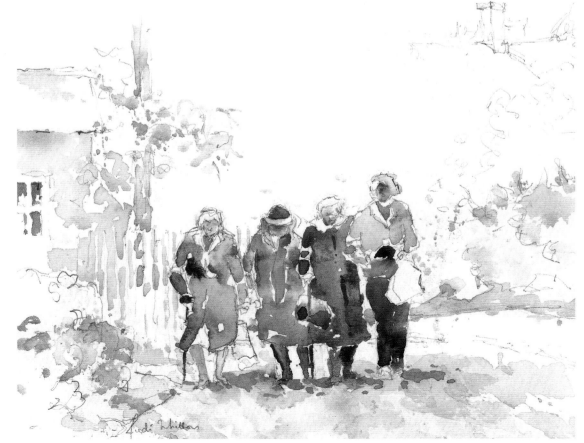

▷ **Lifelong Friends**
20 × 25.5 cm (8 × 10 in)

I painted the figures with the opaque pigments Cadmium Red, Coeruleum and Naples Yellow. To maintain translucency I placed the paint on the paper and allowed it to settle and dry without interference.

Phthalo Green and
Cadmium Red

Prussian Blue and
Burnt Umber

Alizarin Crimson and
French Ultramarine

Permanent Mauve and
Burnt Sienna

◁ Beautiful darks full of colour can be achieved from juxtaposing the pigments illustrated. The swatches show the colours separately with some intermingling on the paper.

Transparency in dark colours

You may have heard watercolour painters say they 'worked up the darks' – in other words, they overlaid washes and built up a dark tone in their work. However, when you layer up paint in this way it is all too easy to stir up the pigment underneath and to muddy the look of the work, rendering it dull and flat. This can also happen if you use one layer of paint but then make adjustments and overwork it, preventing the pigment from settling and drying undisturbed. Always try to achieve your darks with one placement of paint.

To produce a colourful dark you need courage to use sufficient pigment and one application of paint. If you are tempted to use one dark colour straight from the tube you may find the neat pigment too garish, so it is best to juxtapose dark pigments of the appropriate tone and hue. It is vital to have moist pigment in your palette and to tell yourself that this is a one-chance procedure which if approached half-heartedly will not achieve the beautiful transparent darks which make your paintings glow with colour.

Any isolated dark shape will look too dominant, so you should always try to fuse it into an adjoining area or allow it to bleed out into the background.

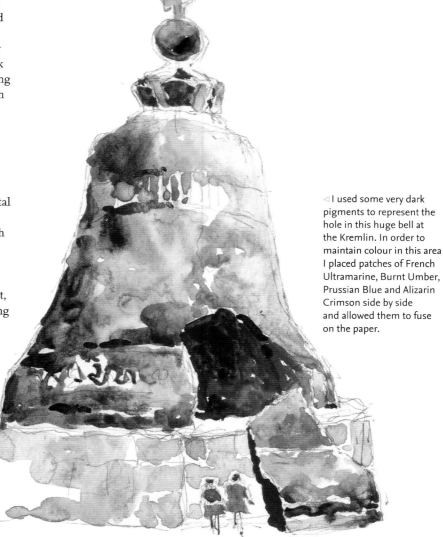

◁ I used some very dark pigments to represent the hole in this huge bell at the Kremlin. In order to maintain colour in this area I placed patches of French Ultramarine, Burnt Umber, Prussian Blue and Alizarin Crimson side by side and allowed them to fuse on the paper.

PROJECT Developing a fresh style

There are subtle differences in paint handling which have a dramatic effect on the finished look of your watercolours. I wish I could analyse the process so that you could quickly get the hang of these deceptively easy-looking effects, but you can only get to grips with the crucial pigment-to-water ratio by means of practice. If you persevere you will be surprised at the lovely results you can achieve.

It is important to take heed of the exact words I have used here. For example, if you read 'place the pigment on the paper', do not stroke the pigment down.

In this project you are going to produce little studies which show the result of varying the methods used to transfer the pigment from the palette to the paper. Eventually you will collect the studies together in a small personal booklet. Remember that the development of your individual paint handling leads to your personal style.

△ Study 2

This study is concerned with picking up two colours directly on the brush together and using free brushstrokes to define positive shapes.

I wetted and shook the brush then dipped it in Burnt Sienna and then immediately in Viridian. Without transferring paint to the mixing area, I stroked the brush onto the paper in one movement to show the form of the leaf. This procedure was repeated and by varying the water content I produced different tonal effects. The two colours produced an exciting result. As the pigments settled on the paper with minimum interference by the brush, the darks kept their colour. The free brushstrokes are a result of holding the brush down the handle and using the arm rather than painting tightly from the hand.

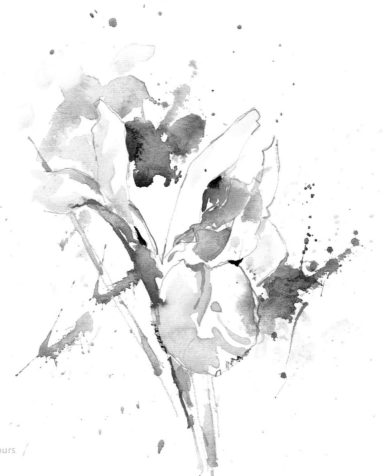

▷ Study 1

The first study shows the effect of picking up colours separately and mixing them on the paper; placing paint upon the paper; negative painting; and avoiding the use of brushstrokes to show form.

After making a brief sketch, I applied paint to the paper and allowed it to mix. With minimum manipulation, I implied hints of petals and foliage. The colours stayed fresh and the indistinct petals and foliage made the painting loose and interesting – but is there sufficient definition?

▽ Study 3

Here patches of varying red pigments denote the poppy petals. Cobalt Blue and Coeruleum were applied separately in the background and allowed to intermingle.

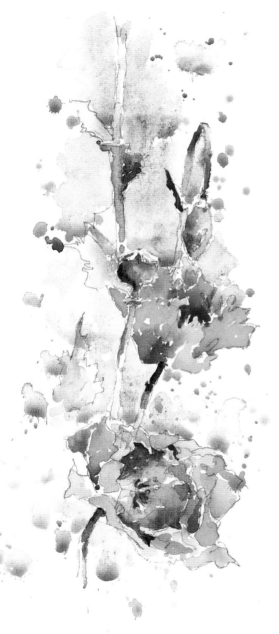

Making a booklet

Collect together a few flowers and leaves and scatter them about in front of you with some overlapping. If you wish, you can use a small viewfinder to isolate the part you are painting.

Ensure that the pigment is moist in your paintbox and use a round watercolour brush of about size 10. Use plenty of water and pigment throughout and do not tamper with the paint when it is on the paper.

Cut your paper to A4 size (29 × 21 cm/11½ × 8 in) and do one study in the centre part of each page so there is room for it to breathe and you will not be distracted by other paintings nearby. You will also have space to expand your painting if you wish. Focus on very simple items and concentrate on paint handling rather than your drawing or colour choices.

Using a hole punch and binding rings, assemble your pages into a little booklet.

It is important that while the paint is still wet you make notes on how you loaded and then handled the brush even when you feel pessimistic about the result. Often paintings can improve when they dry. These notes, together with your verdict, will remind you of how you achieved different effects. Not all your studies will please you, but if you have been methodical in your approach to this project you will learn as much from your failures as from your successes.

△ Having practised these new paint-handling techniques, assemble your studies into a booklet using binder rings. Make notes on how the paint was applied.

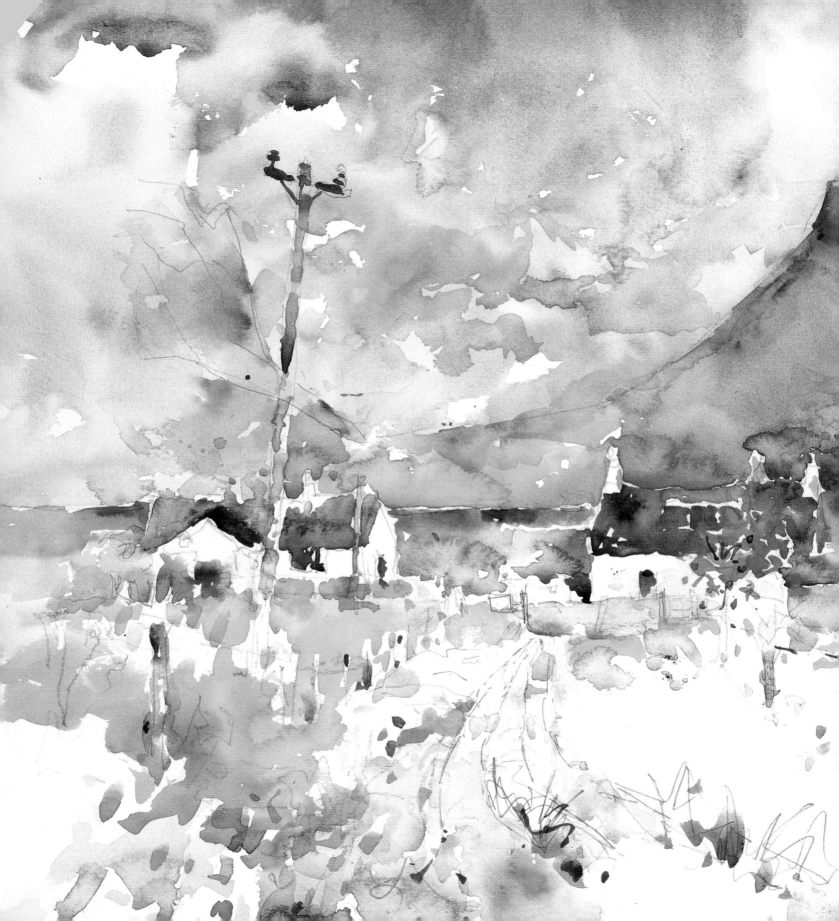

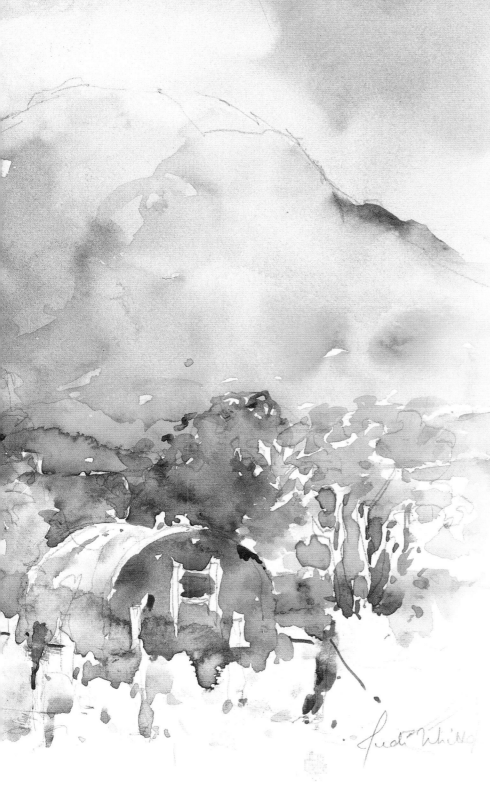

Watercolour methods

There are two elements to painting: one is technical and the other is the more creative side. It would be exciting to devote the whole book to the creative aspect, but you need to have some technical skills in order to be able to translate your ideas to paper. It is commonly believed that techniques should be learnt first, but sometimes you may wish to develop a particular idea and evolve techniques in response to your creative needs – a manner in which Turner worked.

There are no shortcuts and no clever tricks to mastering technical skills. This chapter is mainly concerned with developing this aspect of your painting, but it also incorporates some discussion of the more creative elements.

◁ Threatening Storm in the
West Highlands
33 × 48 cm (13 × 19 in)

Drawing with vitality

If you are not confident about your drawing skills, persevere and attempt to draw everything in the world about you for a while. Just draw for drawing's sake and soon you will begin to love drawing and your skills will rapidly develop. Always remember it is better to have an inaccurate line full of vitality than a stiff and static perfect mark.

When you are drawing for a purpose, for example as preparation for a painting, you may become more self-conscious about your drawing and stiffen up. Strive to loosen up at all times by imagining you are still just drawing for the pleasure of it. I generally prefer to have pencil marks incorporated in the finished painting but if you choose to paint straight onto the paper without drawing it is useful to do a preliminary sketchbook study to assess your subject.

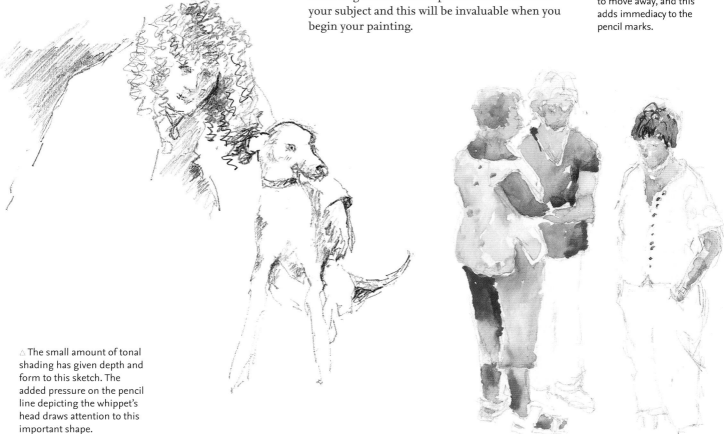

◁ Holding the pencil in this way encourages free marks. It is helpful to have the drawing board quite upright.

Tonal shading
By adding tonal shading to your sketch you can give it a three-dimensional look. Tonal shading shows the inherent darkness or lightness of the colours, together with any shadows. Look through screwed-up eyes to assess the light, dark and mid tones. As you develop your tonal sketch you are observing the relationship between the tones in your subject and this will be invaluable when you begin your painting.

▽ This study shows a slightly hesitant line as the figures were moving about while I was drawing them. In such a situation you are on edge, expecting your subject to move away, and this adds immediacy to the pencil marks.

△ The small amount of tonal shading has given depth and form to this sketch. The added pressure on the pencil line depicting the whippet's head draws attention to this important shape.

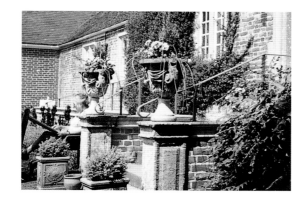

Contour drawing

Contour drawing requires an accurate approach to depicting the shape of your subject. As an exercise, make a contour drawing like mine of the garden urns in the photograph.

Do not concern yourself about composing your drawing on the paper or tonal shading but take your pencil across the paper merely following the observed shapes. Beginning on the left-hand side, trace the outline from the background bush to the low wall and then on until it describes the urn itself with the foliage in the urn. Continue in this way, linking shapes together, across to the right-hand side of the paper. Remember to include outside contours and shapes within the form. Keep the pencil on the paper, holding the pencil still when you look up, then continuing when you look down. This is slow and requires concentration but it is the most true way to observe shape relationships and to prepare yourself for the painting process.

▽ Garden Urns
23 × 33 cm (9 × 13 in)

It is important to prevent the viewer from looking at each urn with equal interest, so I used more paint on the nearer one and on its pillar to keep attention in this area.

△ This contour drawing was an invaluable preparation for the on-location painting by showing links between the wall, urns and foliage.

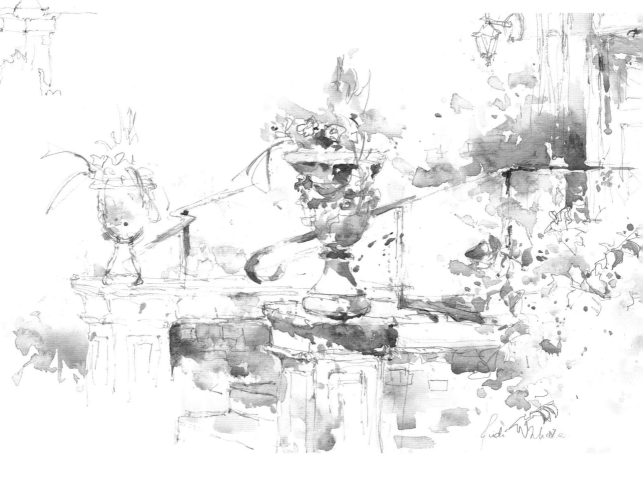

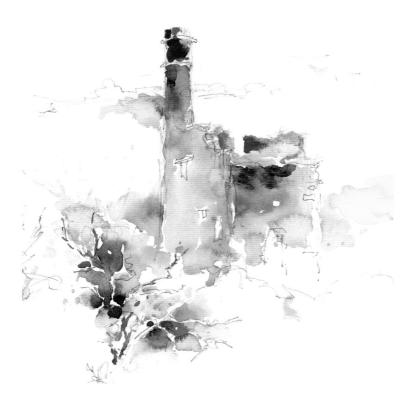

Approaches to painting

For practical reasons, many artists prefer to work from left to right (in the case of right-handed painters) in order to prevent smudging wet areas. However, in general there are no hard and fast rules laid down about where you should embark upon your watercolour painting. You may choose to begin in a certain area just because you have already reached a decision on how you will approach that particular part; you may want to tackle a problem area first, so that you don't spend a lot of time on a painting with the nagging worry that it may go wrong when you reach the difficult bit; or you may decide to begin with a transient effect such as a sudden shaft of light that you wish to capture before it is gone.

Alternatively, you may choose to work forward from the far distance – though if you are not careful to provide linking passages there may be a separation of the far distance, middle distance and foreground that will mar your painting.

△ The first passage of working can clearly be seen in this unfinished painting of a Cornish tin mine. The background hill, the building and some of the foreground foliage were painted in one uninterrupted session of working. This enabled wet paint edges to bleed into adjoining damp washes, thus harmonizing the painting and providing links between the building and the surroundings.

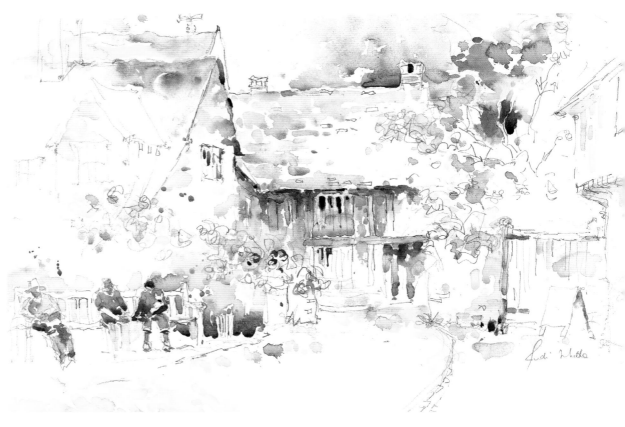

▷ From this unfinished *plein air* painting of Lavenham, Suffolk, you can clearly see the passages of working. First of all the sky and tree on the right were linked together in one passage. The darker left-hand roof was linked to the shaded wall in the centre area and this was linked to the figures on the bench using the foliage on top of the wall.

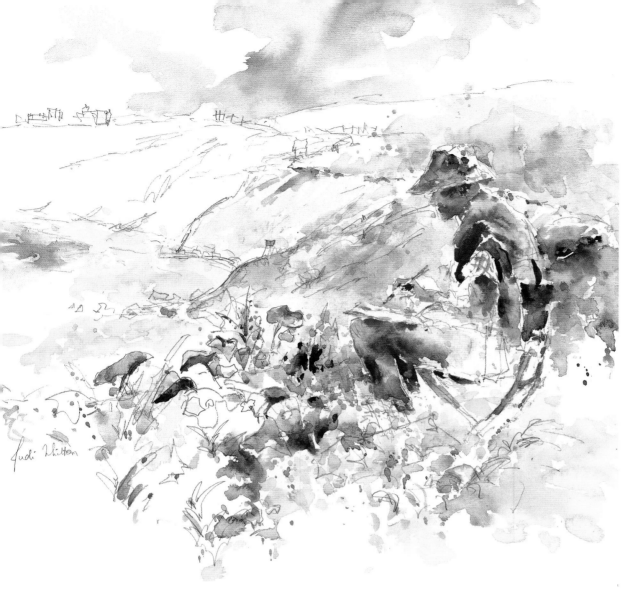

By not totally 'filling in' the person in this *plein air* painting I created an escape which allows the figure to flow into the surrounding grass. There is a smaller escape on the hat, which also links the figure to the distance.

Linking passages of paint

Sometimes a picture fails because its components are not linked together so that the eye travels comfortably through the painting. It is easy to accidentally isolate areas of the painting, with the result that the overall effect is incoherent and the eye is distracted.

If your subject comprises isolated parts, you can encourage linkage by working in 'passages' where you paint an area of the picture in one go, softening edges and linking adjoining parts together. The links can by conveyed by tone, colour or line.

If you complete a solid shape on your picture you may block the link between this shape and adjoining ones. Leaving part of your shape unpainted provides an 'escape' that links into the surrounding areas.

Studio tips

- When you begin your watercolour keep uppermost in your mind how you are going to link areas together.
- Don't take a break during the painting of a particular passage as the paint edges will dry and it will be difficult to merge adjoining areas.

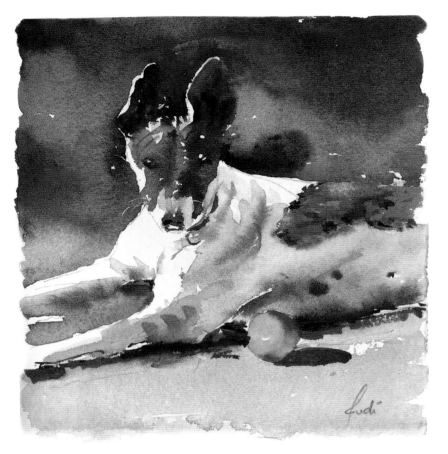

△ Dermot
15 × 13 cm (6 × 5 ½ in)

In this small watercolour
some edges of the red ball
are lost where the tone is
similar to the tone on the
dog behind. The brindle
patch on Dermot's back has
merged into the background,
thus illustrating a lost edge
through blending of paint.

Lost and found edges

Every shape you make has boundaries and if you are
painting an isolated shape then you have decisions
to make about the edges. If you allow the painted
shape to dry you will have 'hard' or 'found' edges.
Your watercolour will look looser and more
interesting if some edges are 'soft' or 'lost'. You can
lose edges by merging wet washes or by painting
adjacent areas with the same tone.

It is desirable to have a balance between distinct
and indistinct edges, though there are no rules to
tell you which edges should be selected. If you have
too many soft edges your painting will have a woolly
look; too many hard edges will give a staccato feeling.

You can use hard edges to draw attention to a
particular part of your composition whereas soft
edges will recede in the picture. If you wish to soften
an edge through merging paint and one of the edges
has dried too quickly it may be possible to bring a
clean damp brush up to the wet edge and gently
tease the paint into the dried wash.

Areas of similar tone
Half-closing your eyes will allow you to distinguish
adjacent areas of similar tone in your subject as
they will appear to be one mass. If you are intending
to lose all these edges using merged paint you could
have problems if the weather is hot and the paint
is drying rapidly. In this case it is useful to
remember that boundaries between two similar
tones will appear lost even though the paint has
not fused together.

FOOD FOR THOUGHT

Before you choose implements for drawing, think about the
type of line that will enhance your watercolour washes. If
you look at the work of John Ruskin, Gwen John, Paul
Signac, Raoul Dufy and John Palmer you will see a perfect
balance between the line and the washes. In Dufy's work
bold ink lines enhance colourful washes, whereas in
Ruskin's and Palmer's paintings a more subtle graphite line
is often used as a perfect complement to the quieter washes.

Pen and wash

The traditional technique of 'pen and wash' describes watercolour painting where ink is applied with a pen as part of the finished painting. There are a number of different ways in which ink can be incorporated into watercolours, or vice versa. You can use either washes or ink first or choose to alternate them as you go along.

You will need to use ink which is not soluble in water. Either buy a bottle of permanent ink and a pen or look for a drawing pen which has 'permanent' written on the side. Try using a quill, too, which will give you exciting marks.

It is very important to keep lively pen marks or your picture may become stiff and static. Be very careful about simply outlining features at the end of a painting. This won't enhance your picture; the ink should be used in its own right to emphasize a dark area or provide calligraphic symbols. However, do not allow strong, enthusiastic pen marks to overpower the watercolour washes.

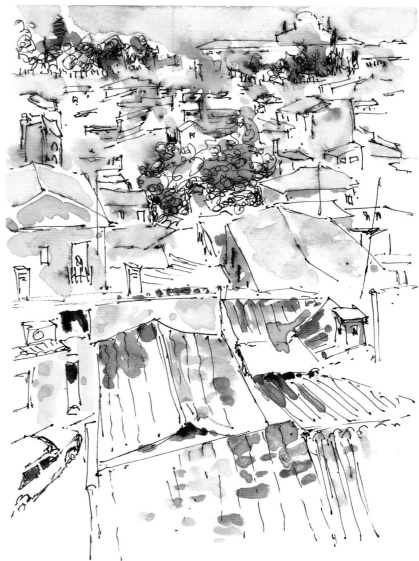

△ City of Toledo, Central Spain
18 × 12.5 cm (7 × 5 in)

I used pen first in this little postcard pen and wash illustration then applied washes of watercolour in the background. Nearer the front, neat spots of paint give vigour and liveliness to the overall look.

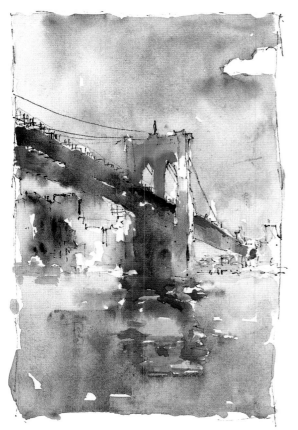

◁ The Brooklyn Bridge
15 × 10 cm (6 × 4 in)

In this small painting a restricted amount of free pen work was used to complete the image. I chose ink in preference to my usual graphite as the watercolour washes were fairly strong and pencil lines would have been lost.

Two core watercolour methods

The majority of painters in watercolour are most familiar with either the 'wash method' or the 'direct method'. Both procedures are described here, because even if you generally prefer one approach to another it is well worth taking time to become accomplished at both.

The wash method

Underpainting provides an opportunity to depict an atmospheric mood and feeling of harmony in your watercolour. Many of the traditional watercolourists of the 19th century favoured this method.

Using this technique, the initial washes are usually pale. They may be of just one flat colour or graduated with several different colours. Allow each wash to dry before laying further washes on top to build up tone and colour. Because of the transparency of watercolour the earlier washes show through the later ones and this can produce some very harmonious effects. Towards the end of the painting you can introduce calligraphic marks to give a sense of completeness.

It is often thought that the wash method is more successful if transparent pigments are used. However, a pigment with a reputation for opacity can be used successfully if plenty of water is added to the mix and the wash flooded onto the paper and allowed to dry undisturbed.

The main difficulty with the wash method is the danger of dislodging previously laid pigments and the work becoming muddied. To minimize this, use watercolour paper with an absorbent surface. Be aware that staining pigments will be disturbed less than granulating pigments in successive washes.

The advantages are that covering all the paper at the beginning removes any inhibition about making initial marks on the white paper; you can set the mood of the painting early on; and you can control tone and colour methodically.

▽ Campiello S. Maria Nova, Venice
23 × 30.5 cm (9 × 12 in)

When the underpainting was thoroughly dry I laid other colours on top to bring form to the picture. The underlying wash gives harmony to the watercolour and creates a sunny atmosphere, although I fear the painting was somewhat overworked.

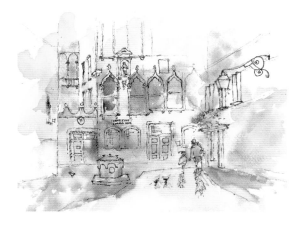

△ Shown here is the underpainting for *Campiello S. Maria Nova, Venice.* My first step was to place a variegated wash of Yellow Ochre, Coeruleum, Burnt Sienna, Cobalt Blue and Permanent Mauve on the paper. This underlying wash was based on the general hues observed in the subject. I used extra strength of colour in some of the shaded areas as good foundation for the subsequent washes.

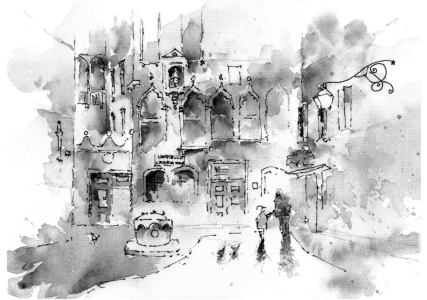

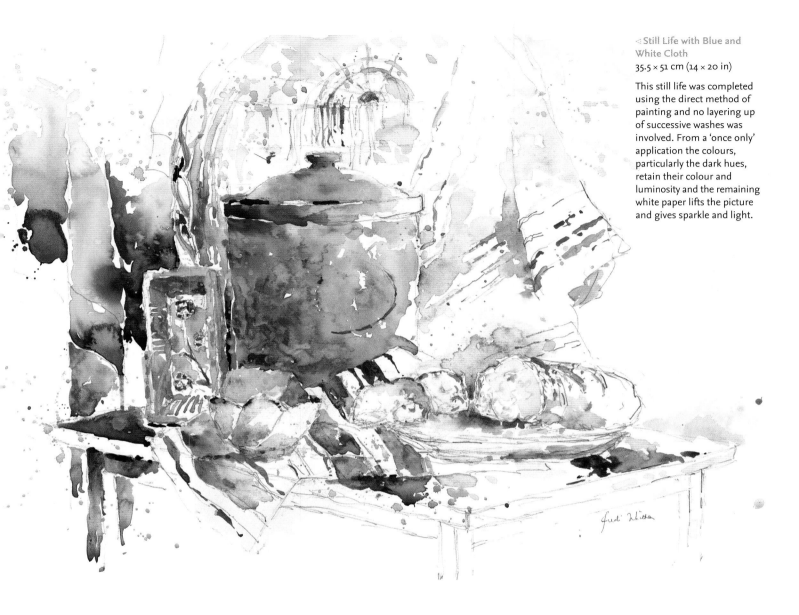

◁ **Still Life with Blue and White Cloth**
35.5 × 51 cm (14 × 20 in)

This still life was completed using the direct method of painting and no layering up of successive washes was involved. From a 'once only' application the colours, particularly the dark hues, retain their colour and luminosity and the remaining white paper lifts the picture and gives sparkle and light.

The direct method

In this method there is no building up of layers of washes; the watercolour is brought to completion without underwashes or overpainting. Paint marks are applied directly to the paper and these will form the finished painting. Small areas of paper can be left unpainted to give sparkle to the work. This method enables the maximum tonal range to be achieved, so it is very suitable for sunny days with dark shadows as it gives excellent rich, dark colours. The direct method is also easier to manage when you are painting outside on a damp day.

Explore further

- Take a very simple subject and, with the same paper and pigments, paint it using each of these two approaches. Take care when using the wash method to allow the effects of the underpainting to be seen in the finished work. Have a look at the pictures a couple of days later, with fresh eyes, and compare the difference in feelings conveyed by the two methods.

Integrating wet paint

In the 'wet-into-wet' technique, a brush full of one colour is laid onto a wet wash of another colour. When the two washes are laid separately onto the paper and allowed to fuse together when still damp this is called the 'wet-against-wet' technique. In general, working wet-against-wet can give more unsullied colour and translucency than the wet-into-wet method.

Both of these procedures involve mixing paint on the paper rather than on the palette. It is always important to use sufficient water and to allow the paint to flow together on the paper with hardly any manipulation with the brush.

The difference between the two approaches is quite subtle and while the pigment is still wet it is difficult to see the effects. By allowing the paint to dry slowly and unhindered you may observe that the wet-against-wet procedures result in more luminosity, with the result that your work will be full of colour and light.

◁ In this study paint was mixed on the paper by dropping one pigment into a wet wash of a different pigment. For example, on the man's jacket Burnt Umber and French Ultramarine were dropped into an overall wet wash of Yellow Ochre.

▷ Throughout this study patches of paint were placed against wet areas of different pigments. For example, in the jacket a patch of Yellow Ochre was placed against a patch of Burnt Umber.

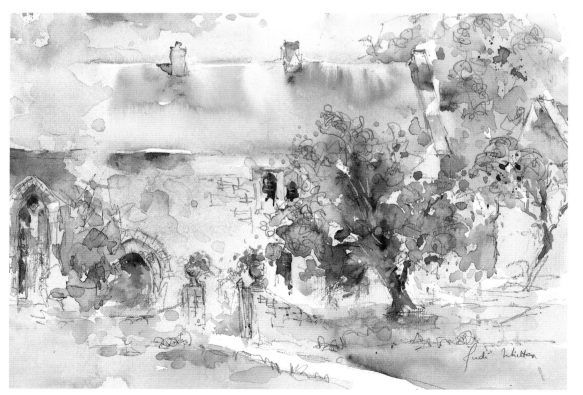

◁ **Sunshine on the Old Manor**
23 × 30.5 cm (9 × 12 in)

In this *plein air* work Coeruleum and Burnt Sienna were applied wet-into-wet under the eaves on the left-hand side above the tall arched window. Both pigments intermingled and led to a dulling of colour. Compare this with the area to the right where the same colours were placed down wet-against-wet, giving an unsullied look.

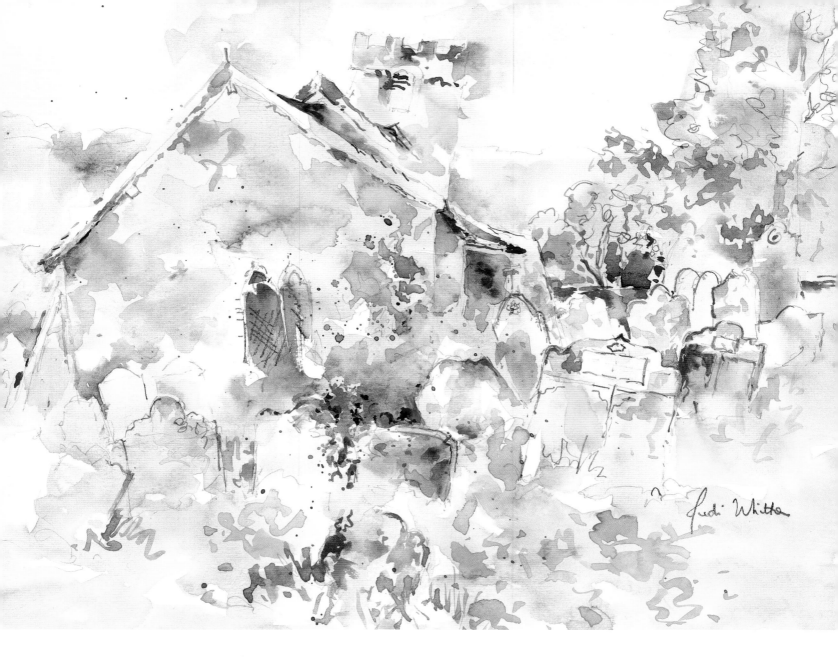

△ **The Little Crooked Church
at Cwmyoy, Wales**
23 × 30.5 cm (9 × 12 in)

By studying the various
patches of paint in this
on-location watercolour
you will be able to see where
the paint has been applied
wet-into-wet and wet-against-
wet. For example, the paint
looks fresher and more
translucent wet-against-wet
on the window than on the
foliage just below, where it
was applied wet-into-wet.

Explore further

- Practise these techniques on scraps of paper.
 More intensity is retained if the pigments do not
 completely intermingle.
- One colour may swamp the other one; if this
 happens reduce the water content of the dominant
 wash and increase the pigment in the weaker one.
- Practise with a variety of pigments in order to
 discover how each behaves.

PROJECT Integrating subject and background

A common mistake is to paint a subject and its background as two disparate elements, which will never result in a harmonious composition. In this project, making an initial contour drawing will help you to give equal importance to all parts of your picture, which will then be carried through into your completed painting.

Find a little vase and put a few flowers in it. Don't try to arrange them carefully for aesthetic effect – a natural look is best. Place it on a table, then sit back and have a good look at it, considering its possibilities as a painting.

Once you have formulated your thoughts, make a simple contour drawing where your pencil traces boundaries, treating the subject and background as indistinguishable and as one design. Put aside your preconceptions of what your subject looks like and concentrate on drawing purely what you can actually see. There will be places where links are made between the object and the background; the rear edge of the table may meet some of the leaves, for example, or there may be a cast shadow upon the table interlocking with the edge of the vase. These interlinking lines will very much depend upon your eye level.

◁ When you select your still life subject remember how useful it is to have elements such as the bowl of fruit shown here which would appear partially cut off in your finished painting.

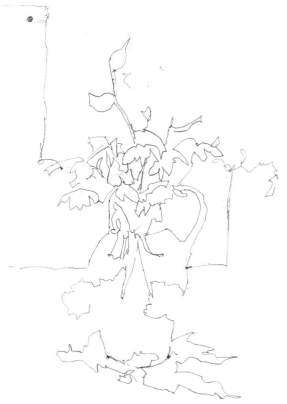

◁ In a simple contour drawing my pencil line traced the observed boundaries, treating the subject and background as equally important. This could be thought of as a painterly drawing where preparations are made for the next stage.

▷ In this practice study of the vase of snowdrops itself attention is given to linking the vase to its surroundings and to avoiding a 'cut out' look for the flower heads by not totally describing them with negative painting.

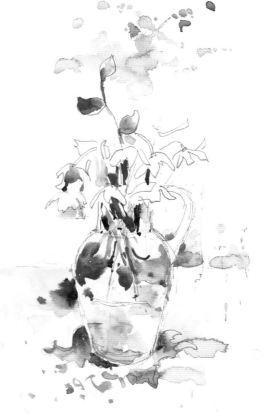

Making links

Turning to your paints, place a shape on your vase (see pp. 34–5). Now move straight to the background and make a shape there, before returning to the vase and flowers. By using the expression 'make a shape' in this context, I do not necessarily mean you to make a complete shape that replicates the observed shape of the tabletop; I am referring to an abstract painted shape that implies the presence of the tabletop by the choice of tone and colour.

Continue to work in this way, giving equal attention to the positive and negative shapes. Look for areas that can be fused together to provide links between the two main shapes and always ensure that the vase can escape into the background at some point; in other words, leave some unpainted shape which flows between the background and vase and allows each component to breathe.

A big pitfall is to surround the vase or flowers with negative painting so that they cannot escape – though an even bigger one is to paint the vase and flowers as solid positive shapes. This would give you a banal result, whereas if you follow the ideas expressed in this project you should achieve not just a competent picture but one that is original and holds the viewer's attention.

▽ Still Life with Snowdrops
35 × 47 cm (13¾ × 18½ in)

Throughout this watercolour I paid as much attention to rendering the background as to the objects in front of it. I integrated all parts of the painting as much as possible to form a complete design.

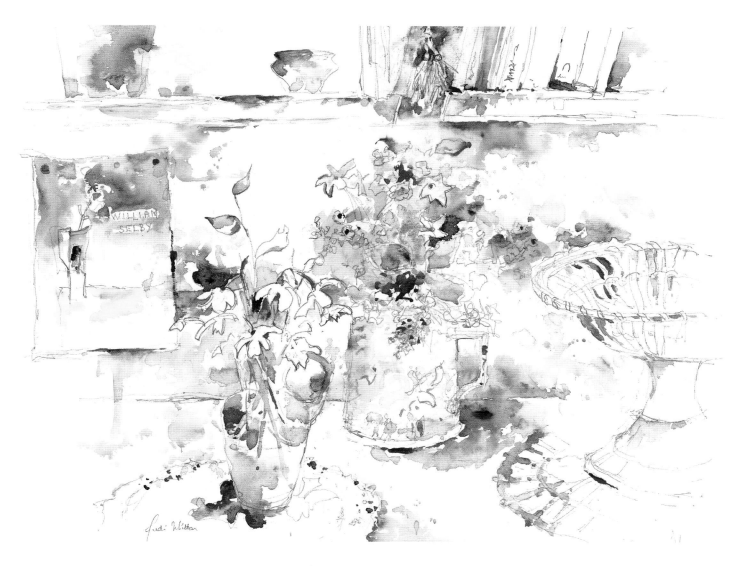

WILLIAM SELBY

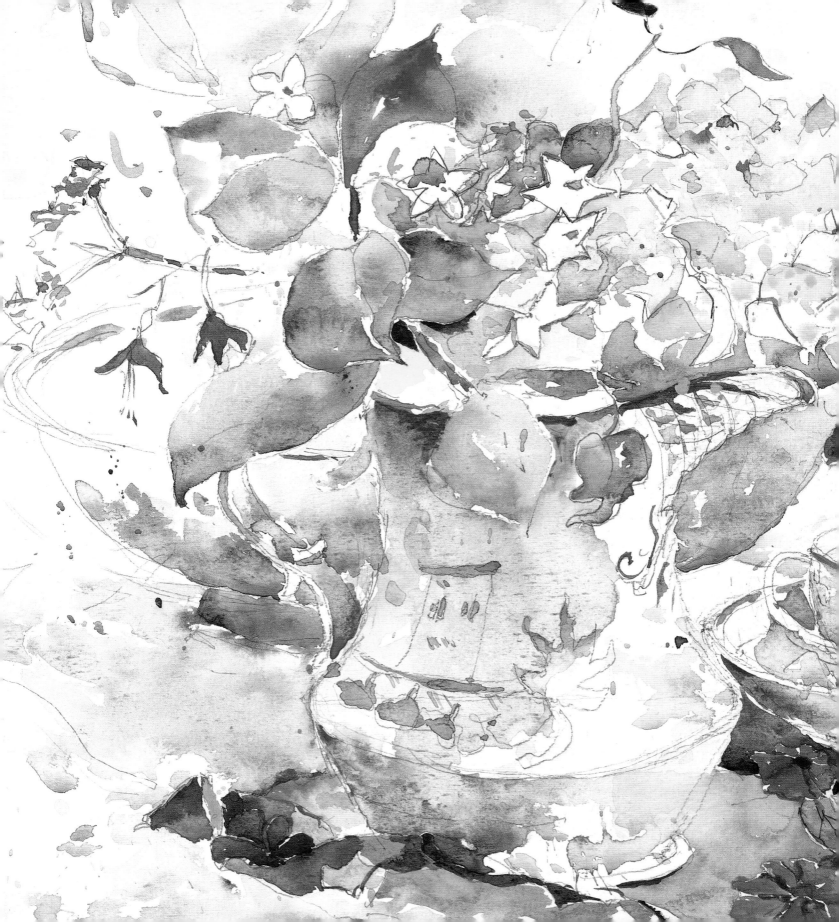

Tone and colour

You can never stop learning about tone and colour. They are your basic ingredients for painting and the more you understand them the better and more immediate your paintings will be.

As artists our lives are enhanced as we develop our sensitivities to the subtle colours in the world about us. It is exciting too when we start to see subjects in terms of tonal arrangements. However, putting it all into practice in your paintings isn't always easy; you can quickly be overwhelmed by the availability of colours and information about the properties of different pigments and their mixing potential. As this is a common problem the general concept of the 'family' of colour is introduced in this chapter to encourage you to develop your natural intuition.

◁ Hydrangeas in a Jug
40 × 48 cm (15½ × 19 in)

Exploring tone

You live in a colourful world, but as an artist you need to train yourself to see your environment in terms of the lights and darks within it so that you are able to use tonal arrangements effectively in your work. Tone plays a vital part in the construction of a good painting; by photocopying paintings you have already completed you will easily be able to see the balance of light and dark tones present, and you may discover that a problematic painting is in fact suffering from an imbalance of tone. Tonal sketching is a useful way to develop your awareness of relative lights and darks.

Tone enables you to show the form and structure of objects and to denote aerial perspective, the phenomenon by which tones become paler as they recede into the distance.

Tone also conveys mood. A painting in a high key, such as a beach scene, is one which contains mostly light tones and often gives an impression of a light and airy mood. A painting in a low key with mostly dark values, such as a locomotive shed, can look foreboding and heavy.

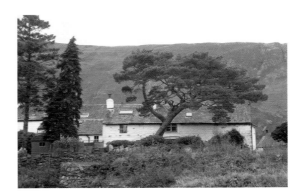

◁ The dark trees provide some beautiful interlocking shapes in this typical English Lake District scene.

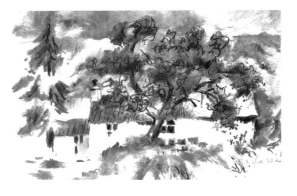

◁ This tonal sketch enabled me to address the difficulty of the roof of the house being the same tone as the hillside behind. I made the decision to reduce the value of the hillside in the final watercolour.

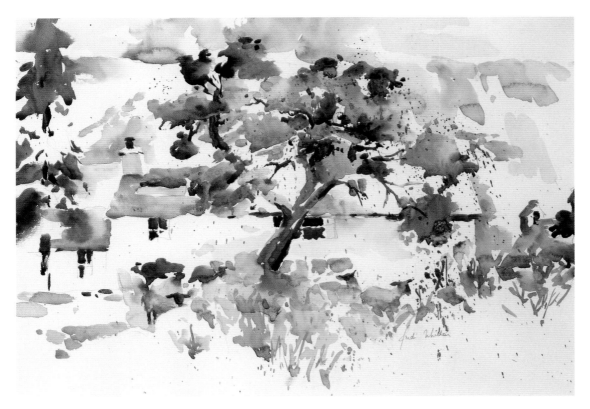

◁ **The Lake District**
30.5 × 45 cm (12 × 18 in)

Strong tonal contrasts throughout this on-location painting give it visual impact. The dark foliage contrasts well with the paler background and attention is drawn to the heads of the sheep by using strong tone.

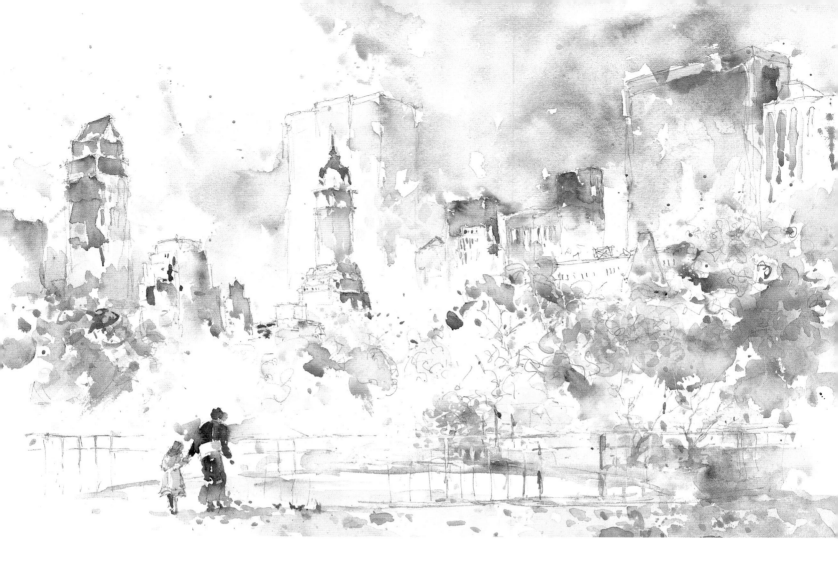

△ **New York Skyline from Central Park**

30.5 × 45 cm (12 × 18 in)

Dark buildings can appear sombre, heavy and overpowering. In order to avoid this and to give a feeling of sunlight the picture was mostly completed in light tones.

The tone of pigments

It is easy to become confused about tonal values when colour is present. Each pigment has its own inherent tone – for example, a strong mix of Burnt Umber will be darker in tone than a strong mix of Lemon Yellow. You will never be able to produce a very dark tone with Lemon Yellow, as the pigment is inherently a light tone. The pigment in Burnt Umber is by nature dark, so this can be used to produce a dark in a painting. However, by adding more water to the pigment a lighter tone of Burnt Umber can be created so that in a black and white photocopy Burnt Umber and Lemon Yellow are indistinguishable in tone.

In order to assess tone it is useful to look at your subject and slowly close your eyes. Gradually all detail and colour will be eliminated and the tones will become apparent.

Explore further

- Find black and white studies from newspapers and, using a dark pen, surround areas of dark, mid and light tone. Try to link areas of the same tone together into shapes and evaluate whether these interlock into a pleasing design (good composition) or whether there is a disharmony (poor composition).
- Exercise your imagination by transcribing one of your paintings from a high key to a low key and vice versa. Remember to keep loose throughout!
- Take an analytical look at the work of the late James Fletcher Watson, who was a master of tonal design in his watercolour paintings.

Understanding colour

Colour is a very personal thing. We all see colour differently, so be cautious about rules; if you become over-concerned with colour theory you may lose your creative intuition.

The most generally useful theory for an artist is that of there being 'warm' colours (yellows, reds and oranges) and 'cool' colours (greens, blues and purples). Further subdivision reveals that within each colour there will be a cool and warm version. You can achieve a sense of depth in a painting by using the phenomenon that warm colours appear to advance and cool colours recede. Indeed the late Terry Frost, noted for his colourful abstract paintings, said that this was the only thing worth knowing about colour.

The mood of a picture may depend on the temperature of the colours used. For overall harmony a 'hot' painting full of warm colours, such as an autumn landscape, may need to be balanced with a small area of cooler colour and vice versa.

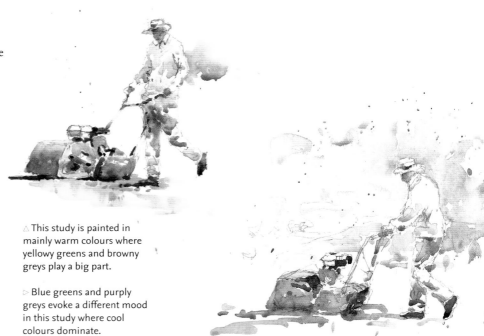

△ This study is painted in mainly warm colours where yellowy greens and browny greys play a big part.

▷ Blue greens and purply greys evoke a different mood in this study where cool colours dominate.

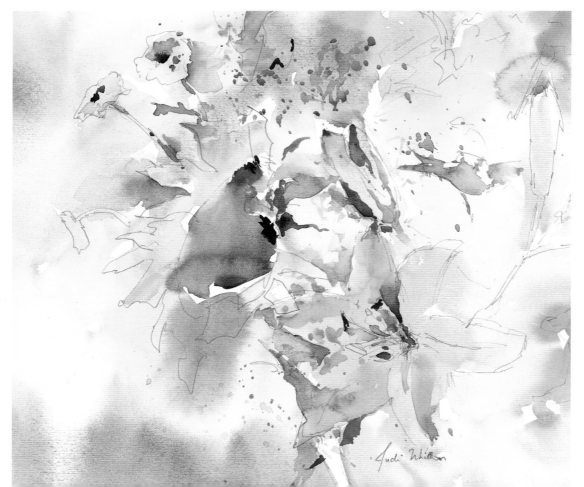

◁ Sunflower and Lilies
24 × 26 cm (9½ × 10¼ in)

The small areas of blue and purple in the background help to balance this painting in which warm colours dominate overall.

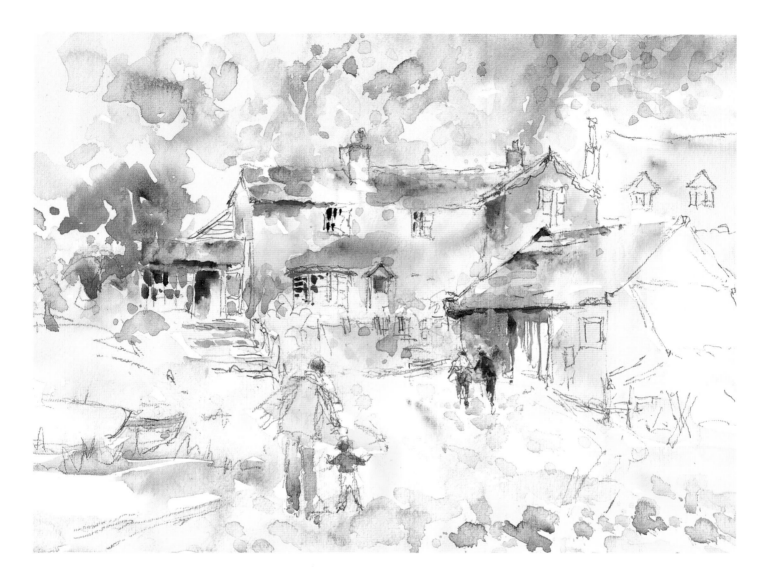

Colour terminology

- Hue refers to the colour name, for example 'red' or 'blue'.
- Colours adjacent to each other (analogous) on the colour wheel are said to harmonize and colours opposite to each other are complementary.
- When complementary colours are mixed together they neutralize each other. When they are placed side by side they enhance each other.
- The intensity (or saturation) describes the strength of a colour. If a colour is greyed-down it becomes less intense.
- The lightness or darkness of a colour is described as the value. Pale colours have a high value, dark colours a low value.

Colour families

Try to trust your feelings about colour. You may have all the colour theories at your fingertips but if your picture doesn't look right these theories are of little use.

To describe your intuitive reaction to colour relationships, try to think of colours in 'families'. Imagine a family of colour for landscape painting and another for flower painting. You have to choose your own family of colour for a painting; if something looks wrong in your picture you might have too much of a colour from outside that family. This concept can also be used to your advantage, as you can draw attention to some part by choosing a restrained amount of rogue colour.

△ The Yellow Shirt
20 × 28 cm (8 × 11 in)

In this on-location watercolour the shirt on the figure was painted in Lemon Yellow, which did not fit into the family of colours selected elsewhere in the painting. This has the effect of drawing attention to the figure.

▽ Campanula
12.5 × 14 cm (5 × 7 in)

In this small painting isolated areas of colour are surrounded by white paper, making the colours glow and giving a lively feel. The direction of the patches of colour gives form to the subject. A little pen work has been added. In a very colourful subject large areas of strong colour are not necessary; small patches of colour can be very effective.

Colourist style

Are you naturally drawn to colour? Do you think 'red' before you think 'tomato'? If you notice 'light' through tone before you notice colour you will probably be a tonal painter. However, if colour is uppermost in your mind when you are painting you may develop a way of putting pigment down that is described as a colourist style. Some artists do not like to have labels attached to their method of painting, but if you love colour there are many exciting ways in which you can achieve colourful loose watercolours.

Using the white paper

In watercolour painting the white paper is your best friend. Placing areas of pure colour in such a way that plenty of unpainted paper is left around them intensifies the hue of the pigment and in turn this emphasizes the whiteness of the paper. The image springs to life, a sense of light illuminates your work and a spirit of freshness is created.

Adjacent colours

The pigments that surround it have an immense effect upon a colour, so the relationship between adjacent colours is more important than the accurate representation of any individual hue. It is these colour relationships that provide a harmonious or discordant look in the finished work. Matisse provides an account of beginning a painting with a red cupboard, then studying the relationship of the red against the white canvas and how that relationship was altered by adding a yellow floor.

While colour theory describes which colours are complementary or harmonious, learn to trust your intuition whether the pigments you are using are expressing your intention in a painting.

◁ Study A and Study B

Both these studies were completed using exactly the same puddles of pigments for the washes. The white paper separating the washes in Study B 'lifts' the colour, thus giving a more translucent and brighter feel.

There is a fashion at the moment for bright and powerfully colourful watercolours. Sometimes it takes confidence to swim against the tide. Seek out the paintings of Gwen John, Hercules Brabazon Brabazon and Berthe Morisot to see inspiring, sensitive watercolours where a restrained use of colour has a brilliance all of its own.

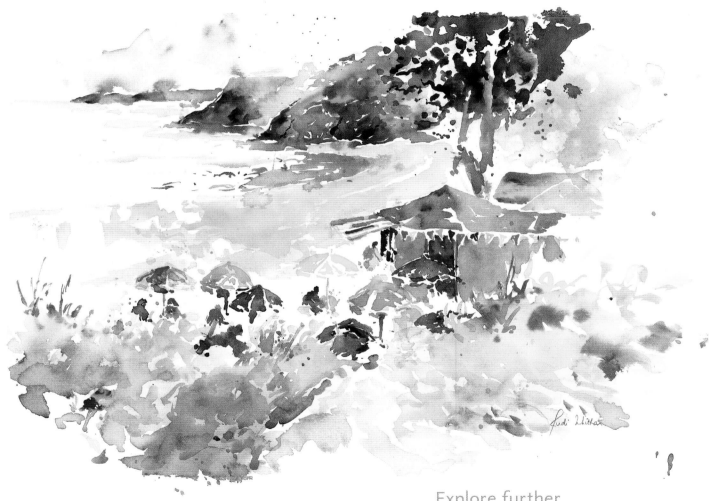

△ Blackpool Sands, Devon
33 × 43 cm (13 × 17 in)

Intense colour plays a major role in this *plein air* painting to give the feeling of a bright summer's day on the beach.

Explore further

- Paint a little study in the style of the *Campanula* watercolour. Remember that each brushstroke is designed to show the flow of the composition but shapes are not filled in, thus leaving plenty of white paper to enhance the colours.

Seeing colour in white

Objects that are white are in fact also full of colour and tone. Observing them carefully and being adventurous is the secret of success to painting them in a convincing way.

When you are painting white flowers it is important not to negatively paint all around the petals as this results in a banal and lifeless painting. Be prepared to take risks; your viewer knows what a daisy looks like so your job is to make it look interesting. You need only hint at the colours and form, and your viewer's imagination will do the rest.

Choosing pigments

When you look at a white subject, such as a figure wearing a white shirt, it helps to screw up your eyes to ascertain tonal variations. Shadow areas can have surprisingly dark tones. Further scrutiny will enable you to detect colours within these tonal areas. Light is reflected on to the shirt so colours in the surroundings will also affect the observed colours.

A palette comprising a red, yellow and blue such as Rose Madder, Yellow Ochre and Coeruleum is very useful for depicting the colours in a white subject. If I see a warm yellowy grey within the shadow area I mix these three pigments on the paper, allowing Yellow Ochre to dominate. Other combinations to consider are Permanent Rose + Raw Sienna + Manganese Blue and Alizarin Crimson + Yellow Ochre + Phthalo Blue.

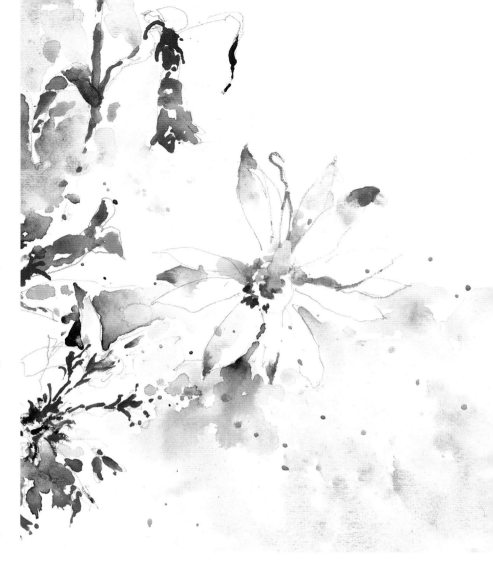

△ White Daisy
(detail)

My approach was based on suggestions of shadows on the petals (Coeruleum, Cadmium Red, Rose Madder) and hints of background areas (Cobalt Blue Deep, Rose Madder, Yellow Ochre and Olive Green), using patches of pure colour.

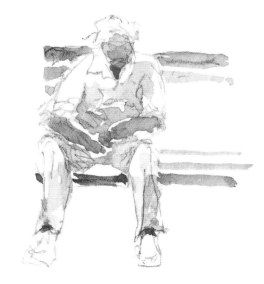

◁ In this small study I mixed colours on the paper to show the shadow areas. Much of the sunlit hair, shirt and trousers were left unpainted; the small areas of shadow and the limited areas of negative painting around the figure were sufficient.

Explore further

- Arrange a little white still life. If you use an artificial light source the colours will remain constant.
- Paint what you see, using three colours mixed on the paper. Keep asking yourself questions such as, 'Is this a blue grey?' 'Is that a yellow white?' 'Where is the darkest shadow?'

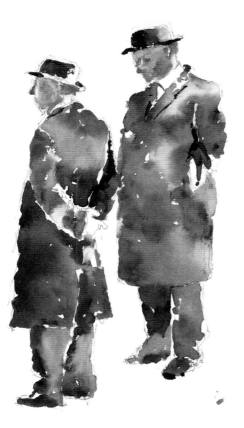

Seeing colour in black

By staring at an apparently black subject, keeping your eyes wide open, you can begin to develop your awareness of the colour possibilities. Light falling on a black surface absorbs all the spectrum of colours and none is reflected, so we cannot see any colour. However, the Old Masters knew how to render a black velvet cloak in a warm black (tending to red) which depicted the texture of the fabric. A cool black (tending to blue) shows a harder surface, while a shiny black surface is depicted using reflected light.

◁ When painting two Cambridge porters in their black coats, I could distinguish light and shade but it was challenging to perceive colours in the fabric. Remembering that the Old Masters used warm blacks for fabric I used French Ultramarine, Burnt Umber and Burnt Sienna, laying them wet-against-wet. My intention was to keep a sense of luminosity and colour.

Keeping harmony

If you have ever incorporated strong black areas such as half-timbering on an old building in your paintings you may have struggled to keep the representation of the black timbering in harmony with the rest of the painting. It is easy to make the timbers look too dark and eye-catching. However, if you look carefully you will see how much colour and light is reflected from the black surface and this can be shown in your depiction of the building. Colours in black are much easier to see in the real-life subject rather than from a photographic reference.

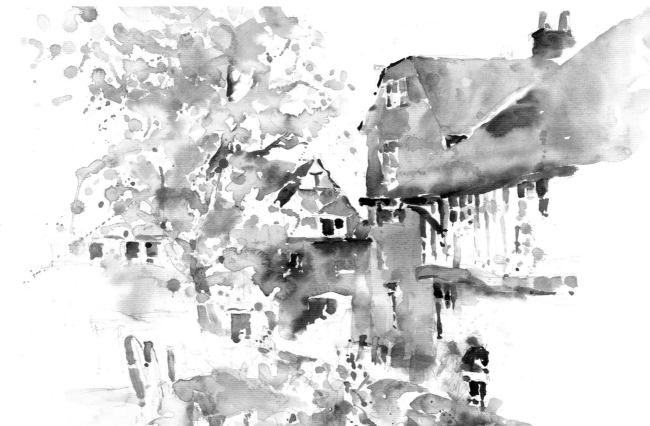

▷ Village in Kent
35.5 × 51 cm (14 × 20 in)

Close observation of the half timbering on this building showed a large range of reflected colour and light. It was important that this was shown and the timbers were not simply painted a flat black otherwise they would have been too intrusive and unsympathetic with the rest of the picture.

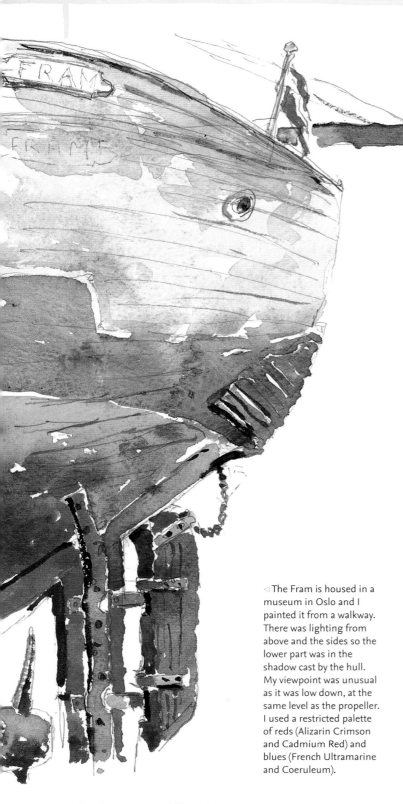

◁ The Fram is housed in a museum in Oslo and I painted it from a walkway. There was lighting from above and the sides so the lower part was in the shadow cast by the hull. My viewpoint was unusual as it was low down, at the same level as the propeller. I used a restricted palette of reds (Alizarin Crimson and Cadmium Red) and blues (French Ultramarine and Coeruleum).

This project has been designed to stretch your observation of tone and colour. When you set out to paint something familiar, such as a tree, it is amazing how much the 'memory' part of the brain comes into force. It is all too easy to paint it from your preconceived knowledge of what a tree looks like, rather than from accurate observation. As an artist you need always to look with the mind of a child, as though you have never seen the object before.

In this exercise you are not picture-making in the sense of designing your painting with the borders of the paper in mind, but merely developing your observations of tone and colour by painting a study.

It is important to find a subject which is new to you, or to find a familiar object and view it from an unfamiliar angle. If you have chosen, say, a piece of furniture for your subject, perhaps you could sit on the floor and view it from below. Alternatively, you could sit at the top of the stairs and look down on an object in the hall. Once you have found your subject, prepare yourself with a piece of watercolour paper and all your usual equipment.

Developing your study

First make a careful contour drawing on your watercolour paper of the shapes you can see. It doesn't matter where you begin, but draw part of the outline of the object and don't be afraid to take the pencil line inside the outline to describe shapes of dark and light tone within it. Screwing up your eyes will enable you to distinguish the pattern of lights and darks more easily. You should be concentrating on these shapes rather than on the object itself.

When you are happy with your drawing you can prepare your paints. To establish the local colour, look at part of the object which is neither in direct sunlight nor in cast shadow. Select two or three further colours to enable you to show the local colour when affected by light and by shadow. Notice how much colour there is within the shadows.

The result of this simple exercise should be an honest study of your subject which accurately reflects the light and shade and, by the use of a limited palette, produces a harmony in the choice of colour.

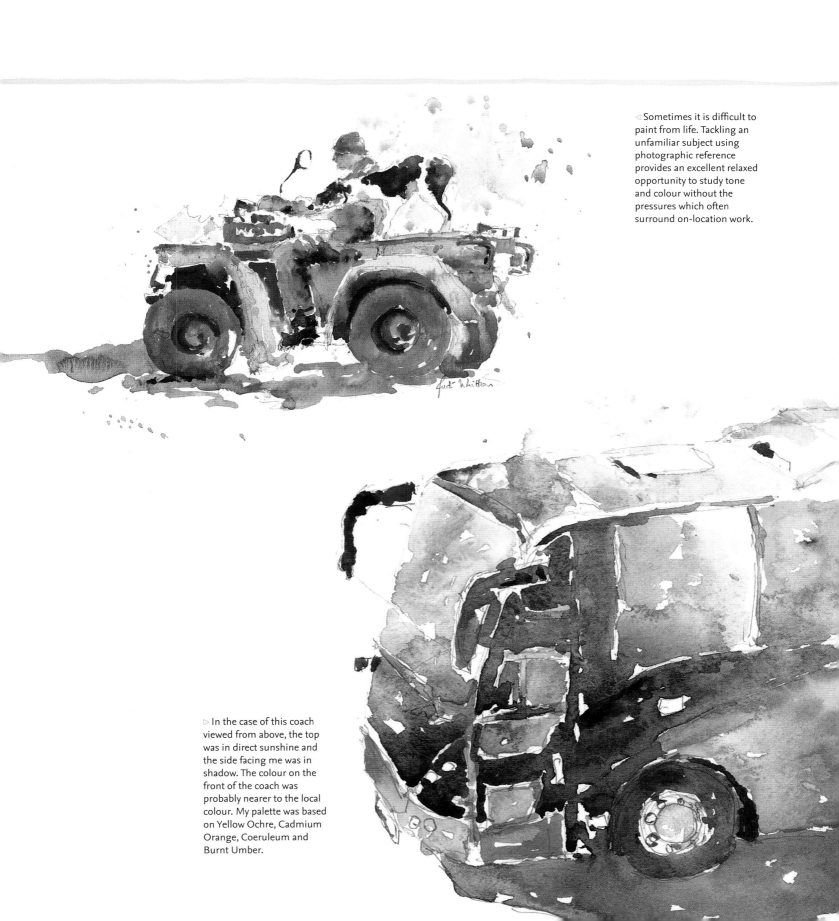

◁ Sometimes it is difficult to paint from life. Tackling an unfamiliar subject using photographic reference provides an excellent relaxed opportunity to study tone and colour without the pressures which often surround on-location work.

▷ In the case of this coach viewed from above, the top was in direct sunshine and the side facing me was in shadow. The colour on the front of the coach was probably nearer to the local colour. My palette was based on Yellow Ochre, Cadmium Orange, Coeruleum and Burnt Umber.

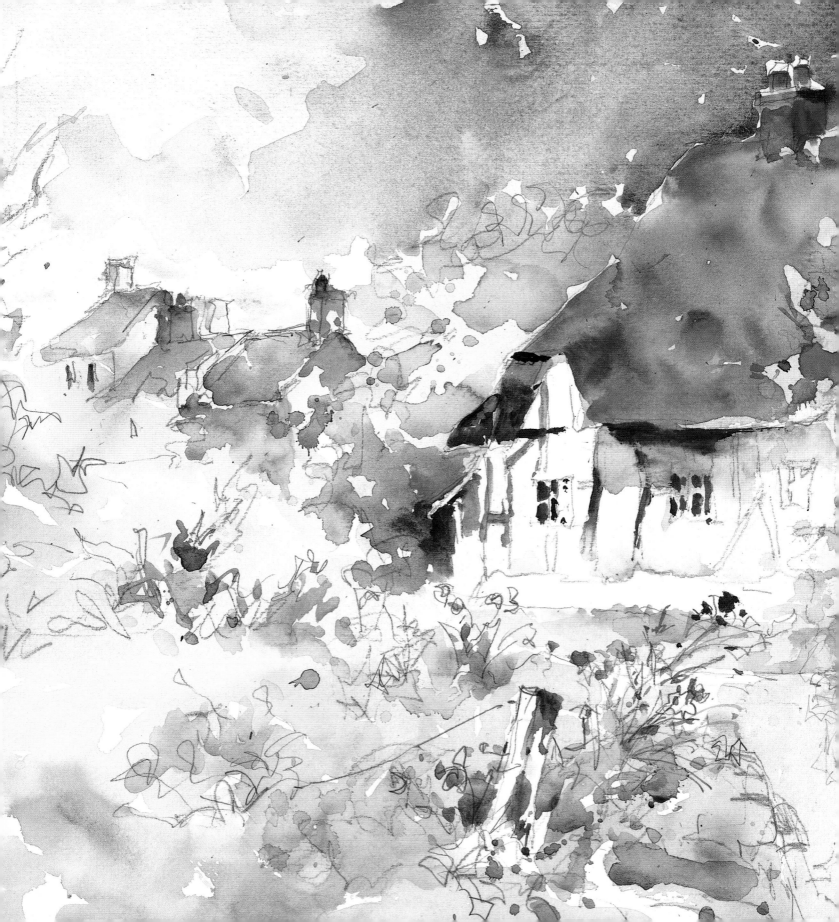

Picture design

Underlying any successful loose watercolour is a foundation of good design and the awareness that you are not painting 'things' but rather constructing your picture using 'shapes'. In the following pages you will learn to see the world around you in terms of these shapes and to understand the importance of line, tone and colour as major design issues. By discovering how to simplify, reorganize and modify the observed world, you will be able to produce spontaneous and exciting watercolours.

Watercolour is a particularly wayward medium and in the hands of an adventurous painter almost anything can happen. While it is important to be aware of compositional conventions, it is also vital to be prepared to ignore them if your picture dictates this.

◁ The Cottage, Urchfont
35 × 51 cm (14 × 20 in)

Designing with line

Designing with line gives a further dimension to your repertoire of watercolour technique. This does not just mean pen and wash, where pen work is used in conjunction with colour and tone. Here you are concerned with watercolours where the line has a strong bearing on the overall design and consequent success of the work. To see inspiring watercolours where vigorous lines enliven the work, look at the paintings of John Piper.

Within 'line' you can include pencil marks or ink lines and also lines created with the brush and watercolour paint. Allow the marks to dominate the composition in the finished work.

If you enjoy using line, flex your wrist to make the pen or pencil dance, introducing a sense of freedom and energy to your work. If the line is wrong, just draw a better one by the side. Several lines can add excitement and mystery.

Varying the line

Lines can evoke an emotional response in the viewer. Circular lines are associated with motion; vertical lines are thought to be more vigorous than horizontal lines, which imply tranquillity. Lines can also suggest recession. According to Ruskin, curves are more beautiful than straight lines and a good curve continually changes direction as it proceeds.

▽ Notre Dame
John Palmer
25.5 × 33 cm (10 × 13 in)

This subtle and sophisticated painting shows John's exciting approach, with lively pencil lines beautifully integrated with the watercolour washes.

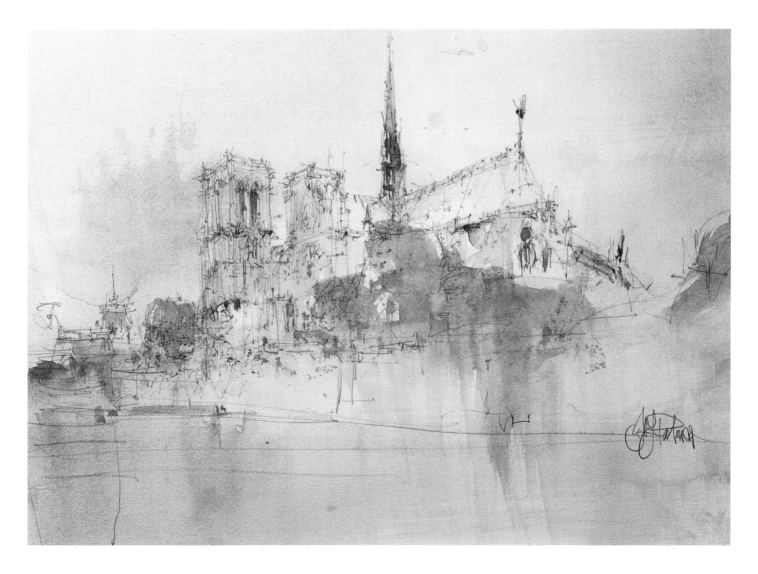

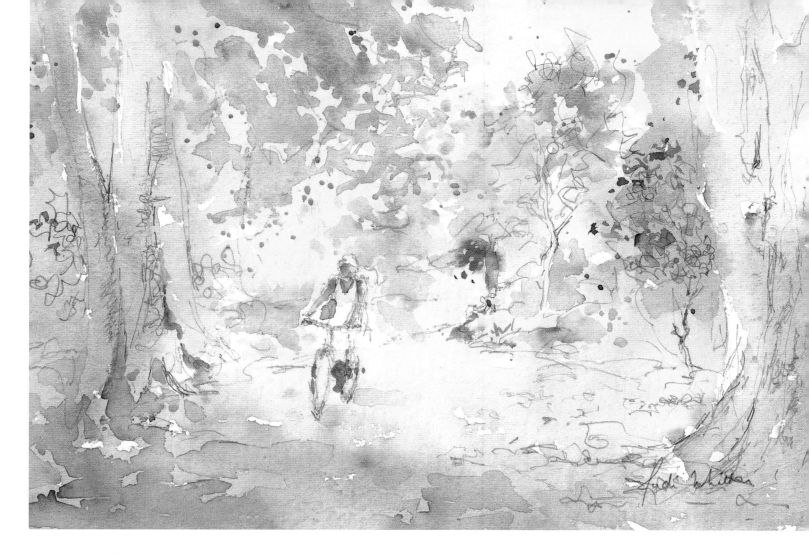

△ Ginny Cycling in the
Woods
15 × 25 cm (6 × 10 in)

This high-key watercolour
was completed using a
narrow tonal range. It relies
upon the pencil lines to draw
the composition together.
The watercolour does not
have strong visual impact
but depicts the soft light in
shaded woodland.

FOOD FOR THOUGHT

Have you ever wondered why a promising watercolour
sketch in your journal does not transpose into a successful
larger painting? The problem may lie in the delicate balance
between the width of the pencil or pen line and the nature
of the watercolour washes. This balance changes as the
scale of the work enlarges. Investigate the various drawing
implements available and broaden your thinking by
experimenting with line, washes and paper size.

Thinking about shapes

The organization of the shapes within your picture provides the building blocks of design. A good design will have a harmonious arrangement of interlocking shapes. Though some guidelines are given below, there are no specific rules to tell you about 'good' or 'bad' shapes and it is important to develop your intuition in this respect. Always remember that the picture as a whole is more important than any individual part.

Positive and negative shapes

For every mark or shape you make you also create a negative shape on your piece of paper. In a landscape, for example, painting a tree forms a positive shape and consequently the sky around it has a negative shape.

This becomes a little more complicated when a positive shape, say a vase in a still life painting, becomes a negative shape when a tea cup is placed in front of it. There are no hard and fast rules, but traditionally the object is thought of as the positive shape and the supporting background is the negative shape. In a flower or still life subject the negative background shape is as important as the shape of the objects themselves.

△ Drawing of positive and negative shapes for *Painting Under the Signpost*.

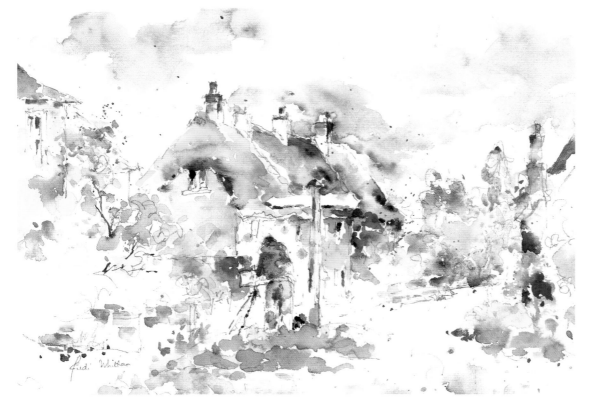

◁ Painting Under the Signpost
28 × 38 cm (11 × 15 in)

In this on-location watercolour the thatched cottage chimneys are depicted both positively and negatively in relation to the sky. The signpost could be considered a positive shape against the background of the roofs or a negative shape, as it is unpainted.

Establishing successful shapes

It is difficult to see the world about you as a pattern of shapes of varying tone rather than identifying the objects you see. However, successful watercolours rely upon interlocking areas of interesting and variable shapes. Fussy detail without consideration of overall design can lead to disappointing results.

A good shape has an interesting form and is in balance with the other shapes in the painting. Try to avoid a static shape, such as a regular triangle, circle or square. Think about the sky; in a seascape, its shape could be a rectangle with no interlocking edge. To make this shape more successful try to 'weight' the sky on one side using a dark cloud, for example. The sky shape above a street scene is easier as it can have an inherently attractive design formed by the intrusion of chimneys and roofs.

It is important to link the light shapes together and also the dark shapes if you can by modifying some of the tones. This will simplify your design.

△ This drawing shows the pattern of light and dark shapes in *Tetbury, Cotswolds*.

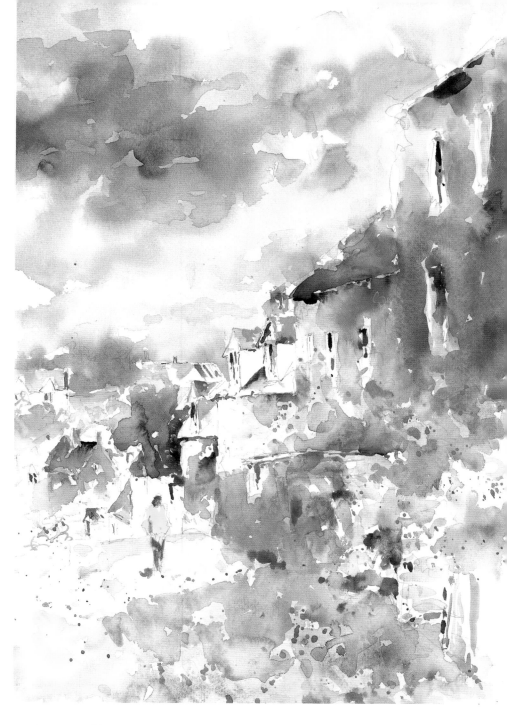

△ Tetbury, Cotswolds
45 × 30.5 cm (18 × 12 in)

There is a simple design pattern of light and dark tones in this sunlit townscape. It is important to allow areas of similar tone to flow together and constantly remind yourself that the picture as a whole is more important than any part.

Designing with colour

Some artists are primarily tonal painters, with contrasts of light and dark forming the basis of their designs. Other painters are first and foremost colourists where colour is employed above anything else. The Fauves could be described as colourists, since they conferred the feeling of a place through vibrant relationships of colour. Indeed Cézanne, who preceded them, represented the hues and structure of nature with planes of pure colour.

Set up a very simple still life subject such as two red apples on a blue plate. With your eyes wide open, look hard to see any colours which might be there in the shadows. It is possible that the shadow side of the red apple has a greenish tinge, while the shadows cast on the blue plate may have a hint of orange. There may also be some reflected light bouncing off the apples onto the plate and vice versa.

When you come to paint your set-up, try to describe the roundness of the fruit using colour alone rather than just darkening the tone of the local colour. Here colour is more important than the lightness or darkness of tone. Extracting the colours you have seen, however elusive, gives you the opportunity to paint like Cézanne.

▽ The Red Boat
16 × 19 cm (6¼ × 7½ in)

The intensity of the colour is the overriding factor in the look of this *plein air* painting.

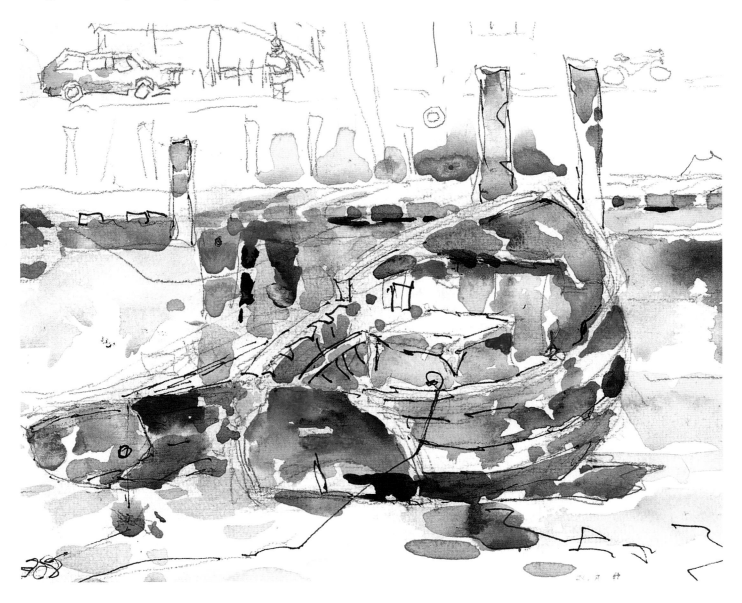

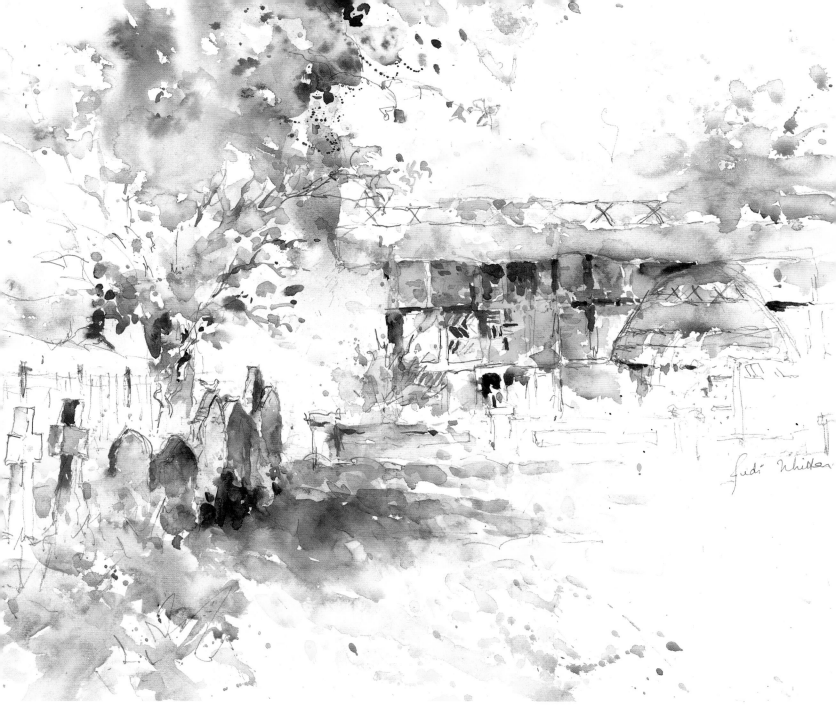

△ **The Red House**
33 × 48 cm (13 × 19 in)

The striking red brick patterns
on the front of this thatched
cottage provided an irresistible
opportunity to incorporate
strong colours in this *plein air*
landscape painting.

Explore further

- Visit art galleries or use the internet to study the work
 of Cézanne and the Fauves. Notice how colour is
 used to denote light and shade.
- Experiment with a simple still life set-up and prop up
 a picture by Cézanne while you are painting so that
 you can observe how he uses colour.

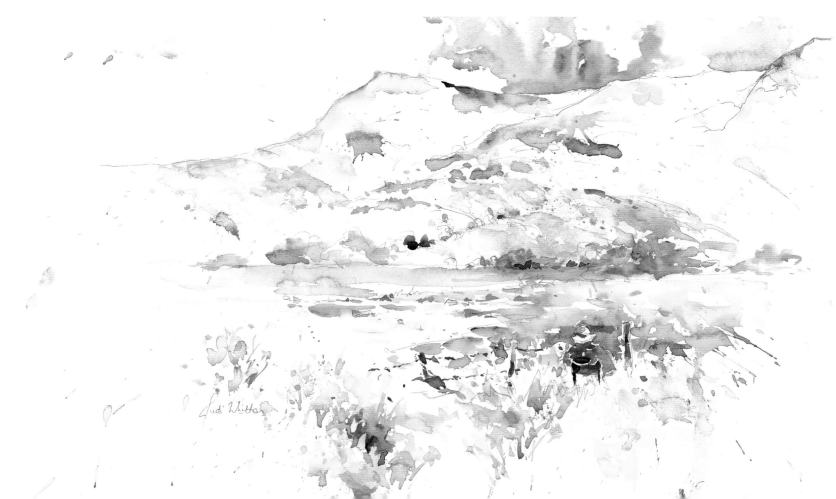

Guiding the eye

Your aim as a painter is to entice the viewer into your picture and provide a journey round your composition from one interesting focal point to another. If you are painting on location and find a wall, fence or gate running across the front of your view, including it in your picture risks shutting out the viewer instead. One solution is to depict an open gate or create a break in the fence. It may be possible to use lost and found edges (see p. 42) to meld part of the wall into the background.

In order to create further pathways into your picture it is useful to find any natural lead in such as a road or river for the eye to follow. Sometimes it is necessary to create an artificial pathway, but take care that this strong directional pull does not lead the viewer out of the picture again. Lost and found techniques will stop the viewer's attention wandering out of your painting. An alternative method is to use a tree or bush to break up the unwanted directional lines.

△ This photograph, taken while I was completing the on-location watercolour, shows the need for an artificial pathway to be created to lead the viewer into the painting.

▽ **Painting the Mountain**
35.5 × 43 cm (14 × 17 in)

As soon as I sat in front of this breathtaking view it was apparent to me that the composition had a very strong horizontal bias. There was no natural lead in, so I created an indistinct artificial pathway by which the viewer could be enticed into the painting towards the seated figure.

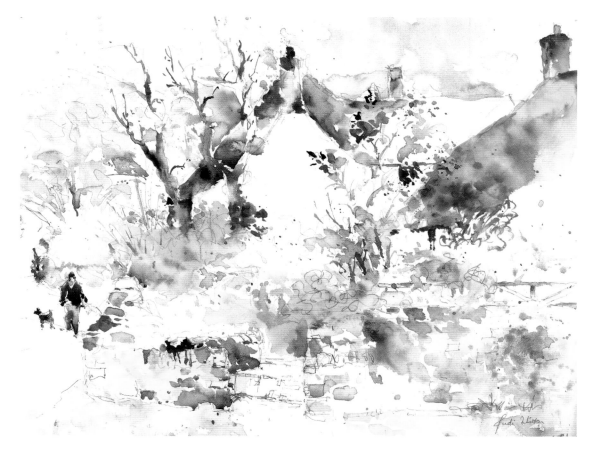

In this on-location watercolour the figure was deliberately placed on the edge of the painting and rendered in quiet colours as this is only one of the accent points. The aim is that the viewer's eye is caught by the colourful thatched roofs, the foliage and the wall and only discovers the figure after looking at these places. The inclusion of the dog walker however gives life to this village scene.

Establishing focal areas

The focal areas in your painting could be a touch of light on a rooftop, the shape of a distant tree or a brightly coloured road sign. Do not worry if a strong detail is on the edge of your picture as long as the painting works as a whole and your viewer is invited back into the picture space.

It is not necessarily a disaster if there is no overriding centre of interest; the overall impression and whether you have got your message across are the most important things. Colours from the same family, tonal similarities or directional lines can be used to link focal elements together. Charles Reid describes how Pierre Bonnard and Norman Rockwell never developed a centre of interest. He stresses that the importance of the arrangement of shapes, colours and tones is the basis of good painting.

In a landscape subject, animals or human figures always attract the eye, so including them is a useful way to guide your viewer around your painting. Certainly an empty and flat landscape can be enhanced by their addition.

FOOD FOR THOUGHT

Although figures are useful for guiding the eye, consider the different messages given by landscapes with or without living things included. In an empty landscape the painter is primarily concerned with the view, while in a work that includes animals or figures the painting may be about capturing a moment of time. John Piper rarely included figures in his landscapes as he was primarily interested in conveying a sense of place, and preferred a timeless quality in his work. Do not feel you have to put figures in townscapes; you may be more interested in the buildings themselves.

▽ The Straw Hat
Charles Reid
43 × 48 cm (17 × 19 in)

In this beautiful portrait the
artist has sensitively balanced
line, tone and colour to
produce a unified whole.

Balancing line, tone and colour

The previous pages have been concerned with
paintings where line, tone or colour dominate. It
is up to the artist to choose whichever way they feel
is best to balance these three dimensions of their
work. However, the harmonious balance needed for
a good painting is not always easy to achieve as tone
and colour can compete with each other. It is vital
too that if line is used with washes neither must
overpower the other. For tonally light washes with
muted colours a gentle pencil line will suffice, while
bold, colourful paintings will require the use of ink.

Finding the dominant element

Overly strong colours and maximum tonal contrast
together in a painting can look brash, so a balance
between colour and tone has to be found. This may
depend upon whether you are primarily a tonal
painter or a colourist, or it may be dictated by the
painting. If you are first attracted to strong colours
in your subject, allow them to dominate and do not
exaggerate any tonal differences. Conversely, if you
have a strongly lit subject or are painting *contre-jour*
(into the light) you will have strong tonal variation
and there is no need to enhance the colours.

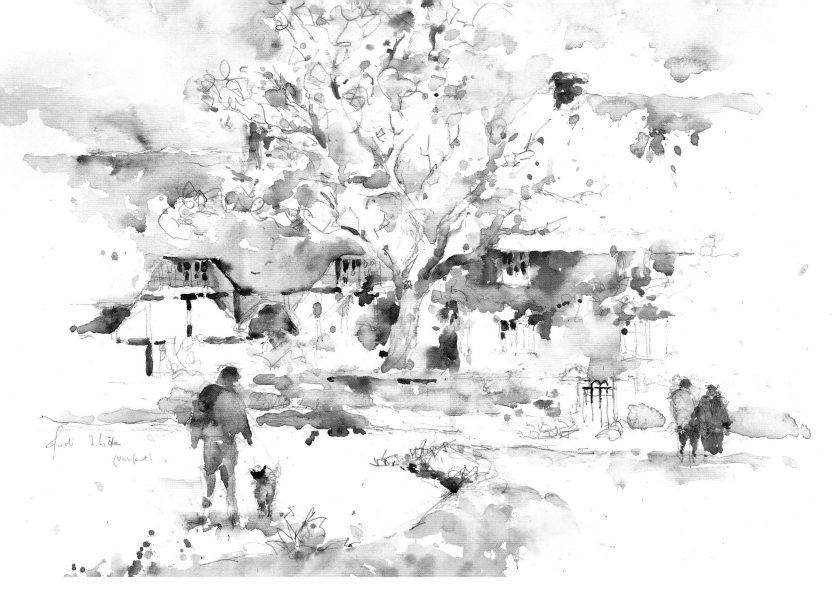

Letting the light in

Watercolour paintings can all too easily become 'dead' and heavy. Restraining yourself from filling everything in will preserve a feeling of freshness and light that will be the envy of your fellow painters.

There are no rules I can impart to tell you what to fill in and what to leave out, but when I am painting I often tell myself to allow the painting to breathe. In other words, if an area is becoming dense and heavy, especially in the heart of the picture, I try not to fill it all in and leave either an area of unpainted paper or complete it with a very weak wash. While you are painting, try to assess whether you are filling in areas needlessly and in general, be cautious about filling in any large, solid objects, such as a roof shape.

△ **Thatched Cottages**
35.5 × 45 cm (14 × 18 in)

This picture was completed on location, though I took a photograph for my records. My concern was that the picture might become heavy if the tree and roofs were all painted in. By comparing the painting and photograph you can see where I restrained myself from filling in some areas and thus allowed my picture to breathe, giving an airiness to the finished watercolour.

PROJECT Rescuing lifeless landscapes

Do you ever feel that your landscapes look empty and reach the conclusion that they might benefit from the addition of people? However, you cannot put figures in without giving some thought as to how they will contribute to the atmosphere you wish to instil and to this end you need to learn how to show movement and body language.

In spite of your endeavours to paint loosely it is easy to tighten up when it comes to adding figures to your landscapes, and it is well worth practising freely drawn figure studies in your sketchbook, working from life. Take a lesson from Lowry, who said, 'When I drew from life they looked alive and when I drew them out of my head they didn't.'

Opportunities to sketch and paint people from life will come your way surprisingly often. Always tuck a sketchbook and pencil or pen in your pocket when you go out so you do not miss an irresistible figure. Your artist friends will make unselfconscious subjects and you will see some of mine incorporated in many of the paintings in this book.

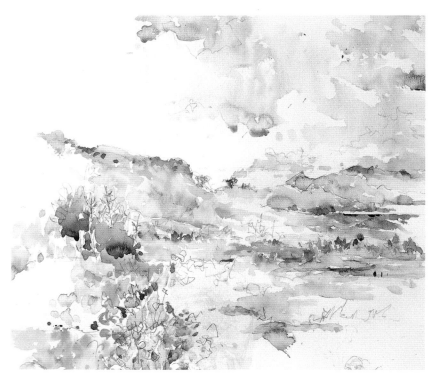

△ View of the Lochs, Scotland 1
30.5 × 35.5 cm (12 × 14 in)

I felt that this empty on-location landscape would be revitalized by the inclusion of figures.

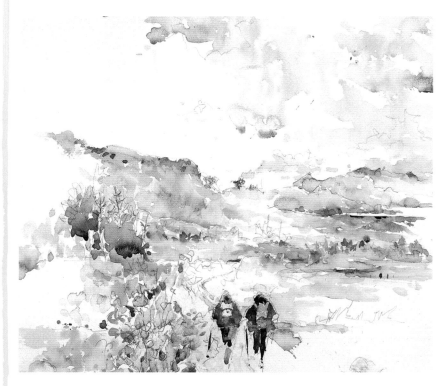

◁ View of the Lochs, Scotland 2
30.5 × 35.5 cm (12 × 14 in)

The addition of two small figures, using my sketchbook studies for reference, has brought this landscape picture to life. As they are walking away the viewer is encouraged to look into the heart of the painting.

Using your sketchbook studies

Take some of your landscapes that seem lifeless and, using your sketchbook figure studies, revitalize them. When you are adding figures into a painting rather than including them from life in the original scene, you will need to take care that they sit convincingly in the landscape. Here are some tips:

• Keep figures in proportion to their setting.

• Heads are often smaller than you expect as the lower part of the face can be lost in the shoulders, especially in cold and windy weather.

• The heads of adults stay at approximately the same level as they recede and the overall figure size diminishes. This is the case if you are standing to paint and the ground is flat.

• A head tilted to one side gives animation – but don't lean bodies so they topple over.

• One leg shorter implies movement.

• Link figures with backgrounds by softening edges.

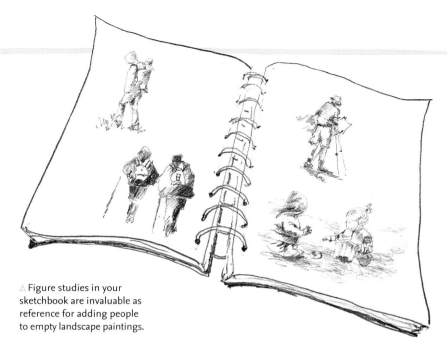

△ Figure studies in your sketchbook are invaluable as reference for adding people to empty landscape paintings.

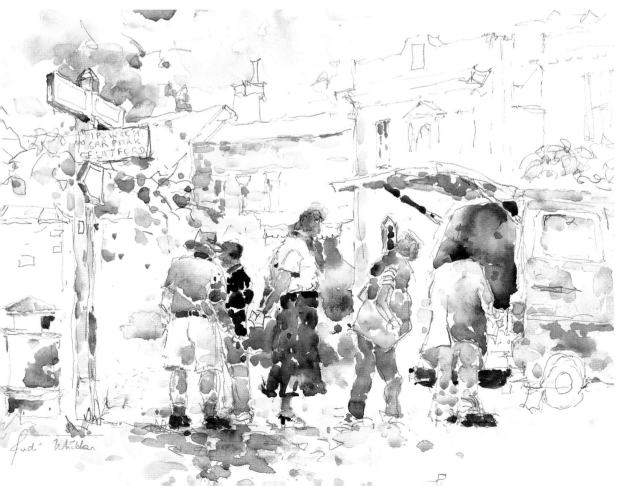

◁ Queuing for Fish
30.5 × 41 cm (12 × 16 in)

The slow-moving queue at a fish van provided a wonderful subject for a painting. I had sketched the scene and half-completed the painting when a traffic accident occurred nearby and help was needed. The van and queue of people had disappeared by the time I was able to return to my spot, but, resorting to my sketchbook studies of figures, I incorporated some of these instead.

Simplifying your pictures

What you omit from a painting is as important as what you put in – in fact, Charles Reid says that good painting is about leaving things out. Highly successful paintings can come from brave decisions that rely on the viewer's imagination.

Some artists, such as John Yardley, do paint truthfully what they see in front of them and are particularly careful about choosing their subject matter. However, in order to prevent their work becoming too detailed and rigid they handle the paint loosely and simplify what they see so that much of the information is reduced to an impression. This makes the painting exciting and interesting for the viewer.

A tried and tested technique for simplification is to squint at your subject, as this minimizes all the detail and enables you to clarify the overall shapes of light and dark in your composition.

Selective editing

Another method of simplification is to make decisions about the elements that attracted you in the first place and just pull these into a design, disregarding other areas. In your individual selection as to what to edit out your personal vision will shine through. Be careful, though, that you do not start adding background just to fill the space, which can become contrived. If you have a great deal of information in your subject it may be necessary to be very selective about what you include and to use your creative skills to organize this into a satisfactory painting.

▷ This photograph shows the lovely setting as the adjudicators sit at their table, recording events at the Young Farmers' Rally.

◁ The Young Farmers' Rally, Crickhowell
30 × 26 cm (12 × 10¼ in)

To simplify this *plein air* painting the estate car was removed and the seated figures were brought nearer to the Land Rover. This was a straightforward way of editing in that one minor object was removed and the general composition was unaltered.

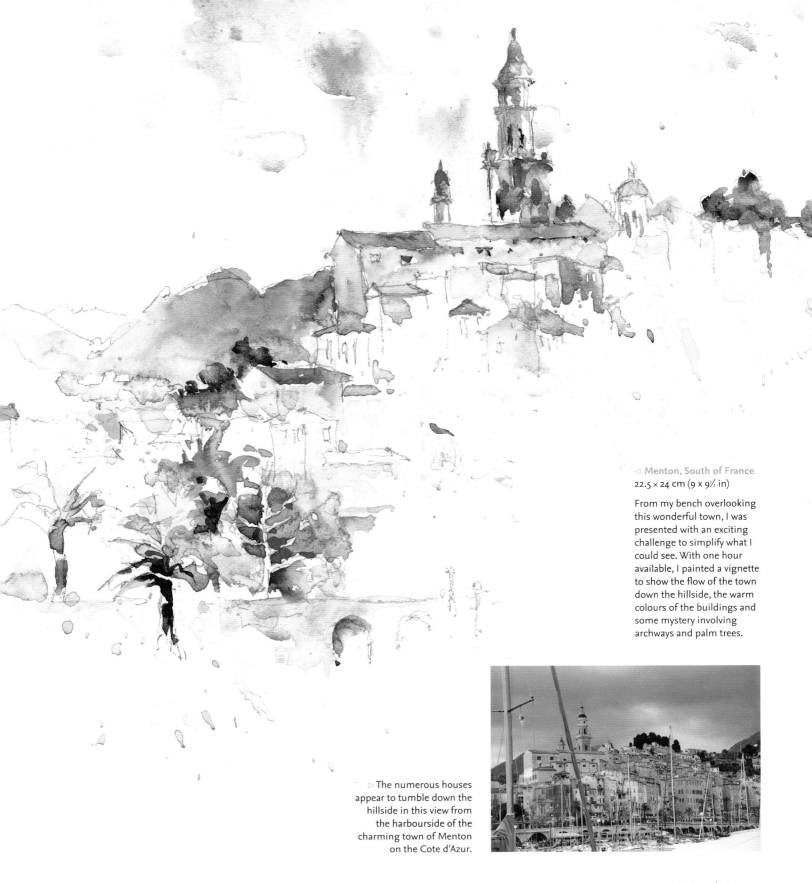

◁ Menton, South of France
22.5 × 24 cm (9 x 9½ in)

From my bench overlooking
this wonderful town, I was
presented with an exciting
challenge to simplify what I
could see. With one hour
available, I painted a vignette
to show the flow of the town
down the hillside, the warm
colours of the buildings and
some mystery involving
archways and palm trees.

▷ The numerous houses
appear to tumble down the
hillside in this view from
the harbourside of the
charming town of Menton
on the Cote d'Azur.

Reorganizing the scene

When you are looking for subjects on location it is easy to feel that you don't like a particular place and can't find anything to paint. However, before moving on elsewhere, take time to consider whether you just need to reorganize your subject a little. Remember that as an artist you are a picture-maker, not just a copier of what you can see.

Changing emphasis

You are in control of any decisions you wish to make about how your painting will look in the end. If you see a light sky but want a dark one you can have it; if you see a crowded street and prefer not to paint figures you don't have to; or if you struggle to paint horses you can have cows instead.

You can modify rules of aerial perspective, composition and colour theory. This may enable you to dispense with inessentials and simplify your watercolours. The rules of aerial perspective are that distant things are bluer in colour and paler in tone than foreground elements, but there is no reason not to emphasize a distant part and play down a nearer dominant feature if that is what you wish to do.

◁ This photograph, taken for my records, shows how I altered the emphasis of the scene in front of me.

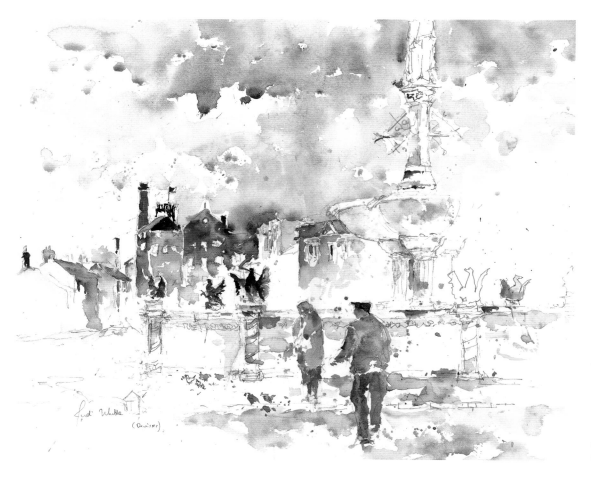

◁ Feeding the Pigeons, Devizes, Wiltshire
35.5 × 51 cm (14 × 20 in)

I painted this picture from within a car. The large dominant fountain in the foreground was played down in order to feature the colourful red brick brewery in the distance. In this painting the rules of aerial perspective are broken in order to emphasize the distant building.

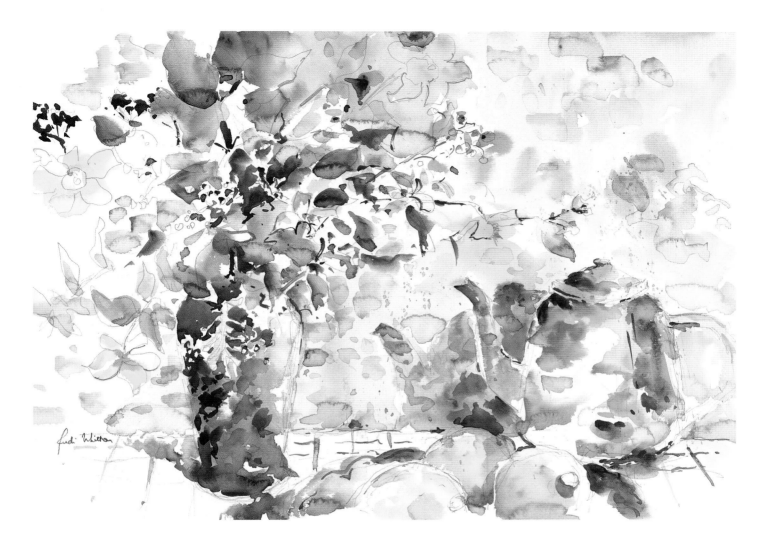

Developing your subject

Even if you immediately like the scene in front of you, try to break away from the safety zone of painting it as true to life as you can make it and develop it further, both to convey your feelings about the subject and to bring a fresh approach.

When I am beginning to develop my ideas about a still life subject, for example, I am often troubled by the thought that I may produce another painting like many that have gone before. I address this in different ways by adding something unexpected, such as an unusual colour or mysterious shape.

To enhance the originality of your watercolour painting it can be exciting to experiment with the background area and create colours and movement which are in keeping with the overall harmony but might make your picture stand out from the crowd.

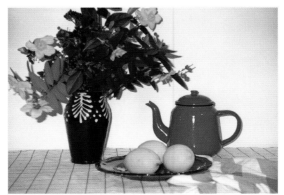

△ The photograph of my
still-life subject shows the
plain wall behind the objects.

△ **The Red Teapot**
33 × 48 cm (13 × 19 in)

This cheerful still life was painted in front of the subject. However, to add some vitality and originality to the painting I developed the background area by adding a background wash and some indistinct patterning.

◁ This photograph of wisteria against a wall is appealing because it shows the flowers in a very natural composition. There is a uniformly flat dark background for much of the right-hand side of the picture.

▽ Wisteria
23 × 12.5 cm (9 × 5 in)

The large area of dark tone that existed in reality could have made the resulting picture too stated and somewhat obvious. To create some subtlety and a feeling of airiness in the heart of the picture, I lightened the tone of the central background area.

Modifying tone and shadow

It is important to train yourself to see the world about you in the sense of tonal relationships and to understand why this forms a strong basis for picture building. However, sometimes the tonal design of your subject may not lend itself to a comfortable composition. In this case, you can omit or modify any observed tones and shadows which are not helpful to your painting in the same way that you can alter features of a landscape.

For example, if you are faced with a uniformly light sky and a flat, dark landscape it might be necessary to create some stronger cloud patterns and exaggerate any lighter areas of the middle distance or foreground to develop a satisfactory painting. In a still life or flower painting you may have a large area of flat tone you may need to modify to make the picture more interesting.

Studio tips

- One of the problems of painting from photographs is that shadow areas can look very dark. It is often better to paint these parts a tone lighter. If you need to see what the shaded areas contain, study the photograph under strong sunlight with a magnifying glass.

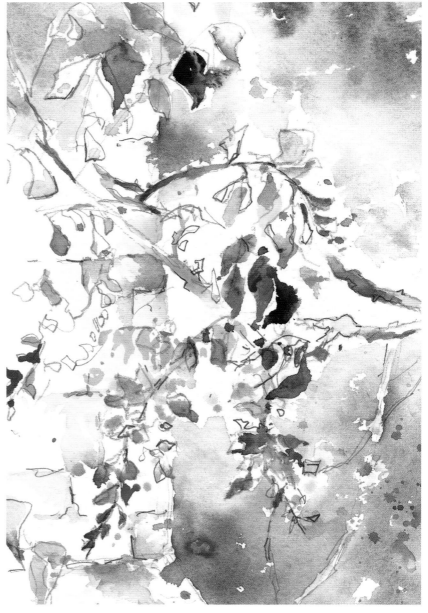

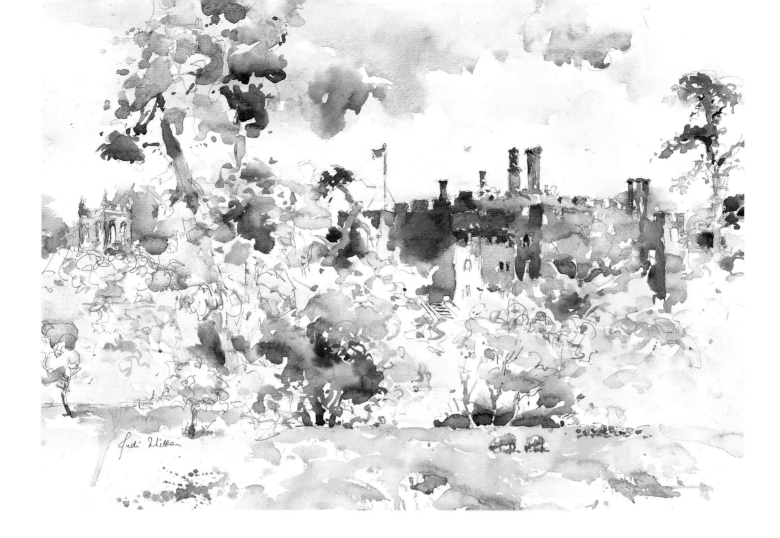

Strong tonal contrast

It is fortunate when the sun comes out and reveals strongly sunlit and shadowed areas as this can lift any flatness of your view and enable you to create a sense of light. Sometimes, however, the shadow forms and tonal patterns may impose on the scene in a way that distracts from your intention.

Consider a street scene where one side is bathed in sunshine and the other side is in dark shadow. It might not be this tonal variation that attracted you to the scene in the first place; it might instead have been the colours of the stones or a figure passing by that first caught your attention. In this situation you might prefer not to include the shadows at all and just paint the whole scene in the local colour. You may even feel your painting would work better if the observed tones were totally reversed in your picture. Remember too the Impressionists, who showed the light and shade in their subject through colour and not through tonally dark shadows.

△ This imposing castle, near to where I live, makes a perfect subject for a painting excursion with friends.

△ Berkeley Castle, Gloucestershire
35.5 × 51 cm (14 × 20 in)

As you can see from the accompanying photograph, in this *plein air* watercolour the tones of the castle and the bank of trees have been reversed. The extent of the foliage was worrying, as it could have appeared dense and uninteresting on paper. To allow the light to flood into my painting I lightened the tree area and this also encouraged me to draw attention to the solidity of the castle by showing it in darker tones.

DEMONSTRATION 1 **The rabbit show**

The judges in the rabbit tent at an agricultural show provided a
delightful painting subject. Sadly I could not paint it from life,
so I took several photographs for reference. I was keen to depict
the tenderness with which the rabbits were handled. Deciding that
using the wash method would show the lovely soft light on the
judges' white coats and reflect the harmonious atmosphere,
I constantly reminded myself not to cover all of this important
first wash with the secondary application of paint.

Colours used

Naples Yellow
Cadmium Yellow
Raw Sienna
Cadmium Orange
(choose one that does not
contain any 'yellow')
Coeruleum
Cobalt Blue
French Ultramarine
Burnt Umber
Burnt Sienna
Vivid Green
Terre Verte
Permanent Mauve

◁ Stage one

Stage one

I drew in pencil on a block of Not paper and designed
the picture with the figures irregularly spaced. The
one on the left was placed on the picture boundary
to contain the subject. I took care with the perspective
of the tent and tablecloth but did not draw attention
to the table top to avoid dividing the picture in two.
I liked the awkwardness of the figure at the back.

Using an old No. 14 round brush, I placed a
variegated wash of Naples Yellow, Raw Sienna,
Cadmium Orange, Coeruleum, Terre Verte and
Permanent Mauve over the entire paper. The
pigments I chose reflected the observed underlying
hue and the warmer colours were placed towards
the front with the cooler colours at the back in order
to give a sense of depth.

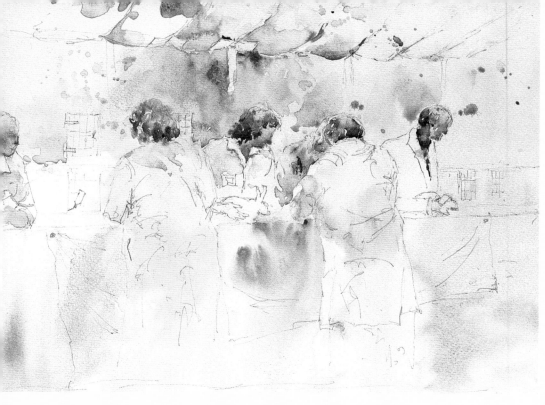

△ Stage two

Stage two

When the underwash was dry I used a No. 12 round brush and placed patches of colour to hint at the structure of the marquee roof, taking care not to repeat the regular shapes of the roof panels. I used stronger blues and purples in the central marquee wall and painted around the head of the figure. With a No. 8 brush I painted the red hair (Cadmium Yellow and Burnt Sienna) so it softened slightly into the damp background and added the face using Cadmium Red, Raw Sienna and Coeruleum. I planned to capture the attitude of the figure, not to paint a portrait. The other figures were completed in the same way but paler washes were used on the figure on the left so as not to draw attention to him.

Stage three

Using the No. 12 brush, I placed Coeruleum and Cadmium Orange wet-against-wet on the tablecloth. Unpainted shapes were left to denote the curved folds in the cloth. These important fold patterns provide movement in the painting and encourage the viewer's eye to travel round the picture. I painted some shadows and folds on the white coats and in places these were allowed to run into the wet tablecloth, allowing the two areas to be married together. These 'greys' were made by placing blues and browns wet-against-wet. Some extra pencil work was added here and there.

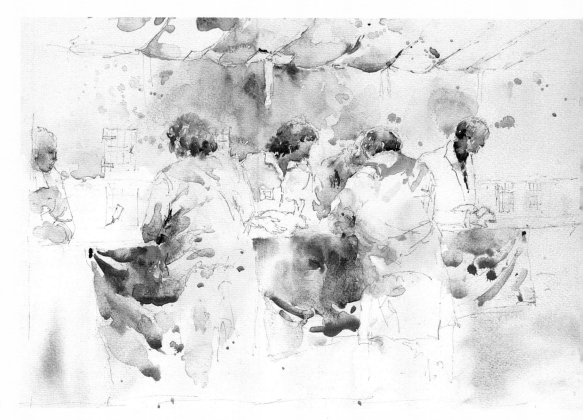

▷ Stage three

Stage four

I completed the central rabbit with Burnt Umber
and French Ultramarine, using a No. 8 brush.
I adopted the unusual procedure of incorporating
a 'cut-out' shape as the rabbit was small and crucial
to the design of the picture. The judge's hand was
painted carefully to show how it caressed the
animal. Vivid Green provided a bright touch in the
water bottle and judge's badge. The lop-eared rabbit
on the right was rendered simply in weak washes
to avoid drawing attention from the central rabbit.
I added important details such as the rabbit
hutches and drawing pins securing the tablecloth
then, returning to the No. 12 brush, put in the
grass in the foreground.

▷ The Rabbit Show
30 × 35.5 cm (12 × 14 in)

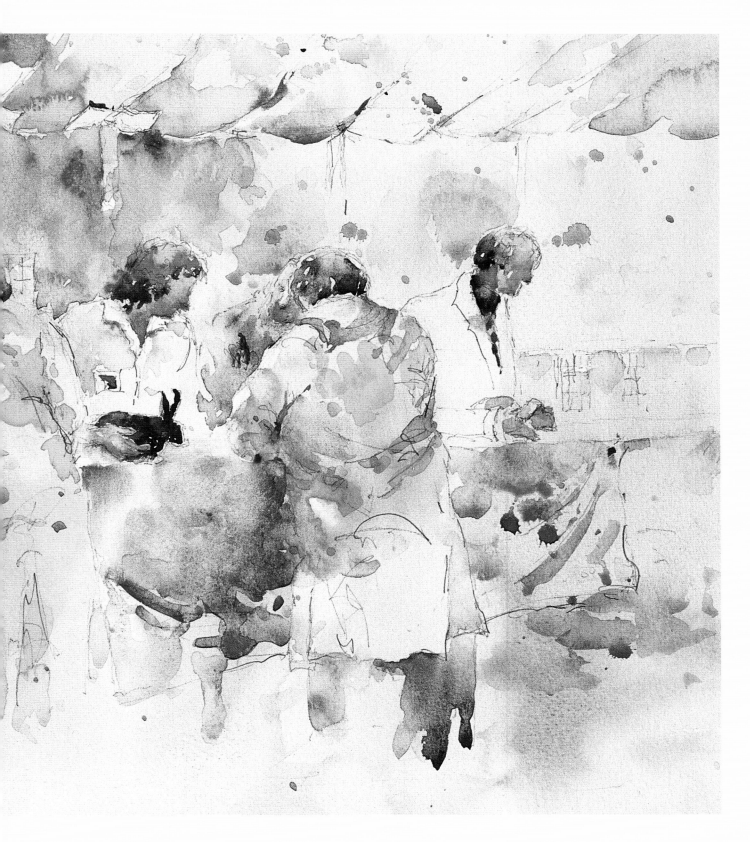

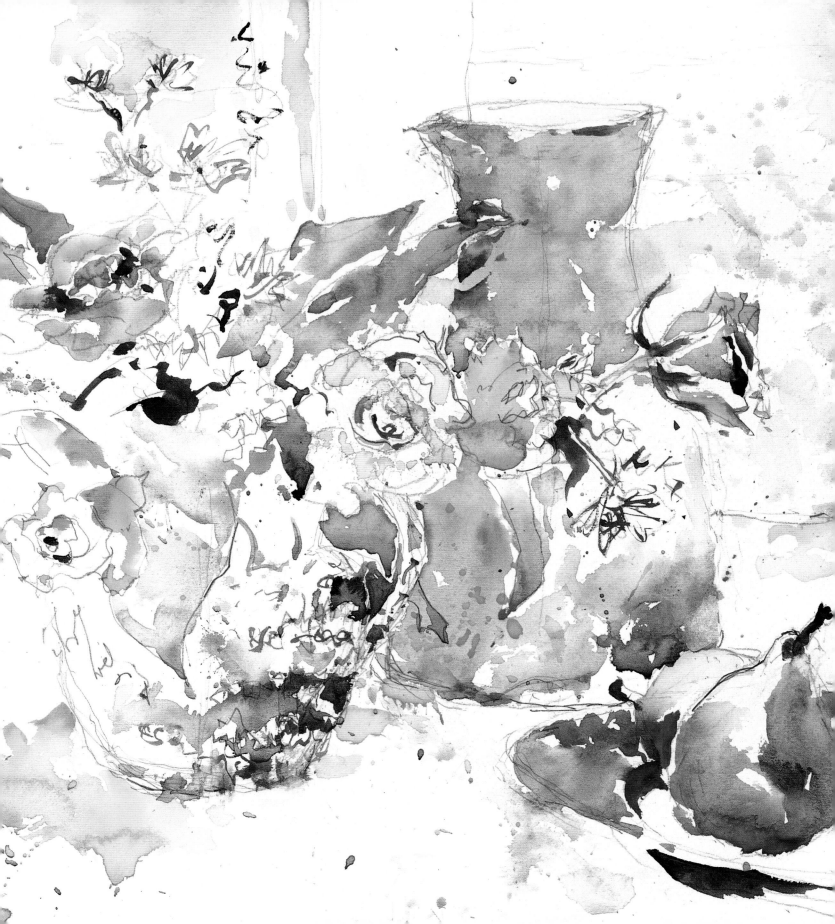

Painting vignettes

A vignette is a painting in which significant areas of white paper are incorporated in and around the finished image. When these areas are well designed, as part of the composition, the resulting watercolours are flooded with light and have an exciting sense of spontaneity and freshness. Vignetting gives a marvellous emphasis to the subject and provides wonderful opportunities to design the painted area within the picture space.

In this chapter we shall be looking at why you should choose to paint a vignette, how to design the white spaces, how the painted area meets the border and whether the painted edges should be softened. Hopefully it will open your eyes to an exciting new way of painting free watercolours.

◁ Still Life with Three Pears
35 × 50 cm (14 × 19 in)

What is a vignette?

In Victorian times, paintings in which the outer edge of the image was softened where it met the white paper were called vignettes. Indeed, in the world of printing and photography the word 'vignette' can describe an image with softened edges. In this book, however, I am using the word 'vignette' as an accepted artistic term to describe pictures where a painted shape, not necessarily with softened edges, is placed in an exciting position on the paper so that unpainted paper within and around the subject enhances the overall design. To provide good abstract negative shapes the painted part should touch the border in places.

Some painters feel the need to fill in any white paper. There is nothing wrong with this, except when you would prefer to leave white spaces but are unsure how to do it. Strangely enough, it is quite hard to leave areas unpainted and for a vignette they should not happen by default: the unpainted abstract shapes are designed in order to be part of the finished composition.

▽ **Manor Farm**
33 × 48 cm (13 × 19 in)

In this on-location vignette some elements of the subject were extracted while other areas were ignored. The painted areas were designed to link together in such a way that the painting flowed across the paper. I was always aware of the shape of the unpainted parts and these were also designed to be part of the composition. In this way the watercolour painting is represented as a vignette.

◁ **Tall Clock**
23 × 10 cm (9 × 4 in)

This little from-life illustration is not a vignette, since I made no effort to design the subject within the picture space. In other words, the negative spaces around the clock have not been designed in any sense and no background features have been incorporated.

◁ Yellow Flowers
23 × 26 cm (9 × 10¼ in)

In this vignetted flower painting the petals, stems, background and unpainted spaces are woven into an overall design.

▽ The Horse Show
23 × 25.5 cm (9 × 10 in)

Although this is a fairly brief painting it is not a vignette because there are no abstract unpainted shapes left which contribute to the composition.

Studio tips

• If you feel worried about leaving abstract unpainted shapes in your watercolour paintings, start in a very limited way and just vignette the foreground area. For example, rather than take the sand on a beach scene to the corners, try just to sweep in the central part.

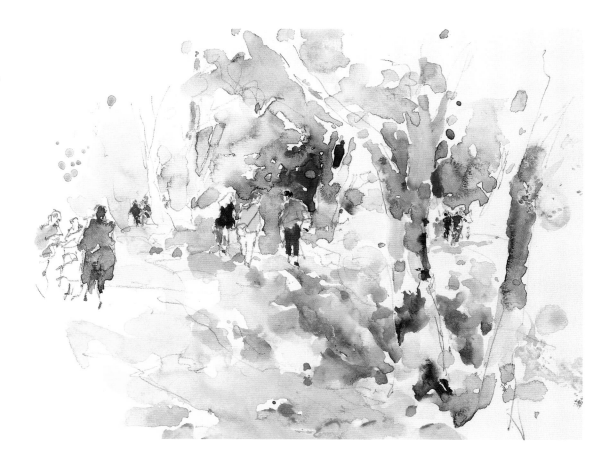

▷ Woodland Gathering
14 × 19 cm (5½ × 7½ in)

This simple vignette is anchored within the border by the grass at the bottom, the group of figures on the left and the tree at the top. The top link to the border is played down to keep the viewer's attention on the central group of figures.

Anchoring a vignette

In order to anchor your vignette within the picture border the painted parts should meet the edge on several sides. This also ensures that there are interesting unpainted shapes around your vignette and provides a unique opportunity to introduce visual movement into your painting; you can choose how to take the painted part out to the border and in this way movement, direction and flow are incorporated into the picture design.

Designing a vignette

Among the rules I have read about painting vignettes is one that states that some of the painted part should meet the edge of the paper on three sides. Where this occurs it should not involve a long part of any of the three paper borders.

My attitude to this sort of rule is to allow your intuition to take precedence and if it looks right to you that is all that matters. If you are having difficulties with designing your vignette within the picture boundaries then this is the time to go back to this rule and see if it helps. Always be aware that if the painted parts are the positive shapes and the unpainted parts the negative areas, the design of these parts within the picture boundaries contributes to the overall design of your picture.

Explore further

- Do you have a drawer containing paintings which didn't quite work for one reason or another? Take a good look at one and decide if there are any areas which aren't really necessary for the overall result you had in mind. Using scrap paper, tear out shapes to cover these areas. Can you instil new life and vigour into your piece of work? If so, repaint it as a vignette.

Different ways of finishing

Despite limited time I was determined to paint the magnificent corner in the Old Town area of Stockholm shown here. The buildings were so interesting and I concentrated on the colours of the plaster and the pattern of the exposed stonework. There was just time to include a few figures and then I had to go! My painting was near completion but I could not rush making the all-important decisions about how the painted part should meet the border. I needed to establish links with the edge of the picture in order to provide a satisfactory design of the unpainted areas and thus make a successful vignette rather than an apparently unfinished painting. Now I am looking at it, some time later, I cannot decide on the best way to complete the vignette. Which of the two trial studies shown here do you think works the best?

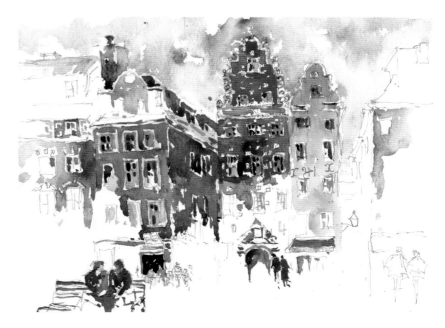

▷ In this trial study to help me make up my mind how to finish the Stockholm vignette I filled in some of the central foreground to lead the viewer into the composition and to provide a link with the bottom edge. I decided against completing the building on the right and taking it out to the right-hand edge as it would be too similar to the building on the left of the picture.

▷ There were two nice figures pencilled in on the bottom right-hand corner of the original painting. In another trial study I decided to paint these and complete this area of the painting, thus providing a short link to the right-hand and bottom edge.

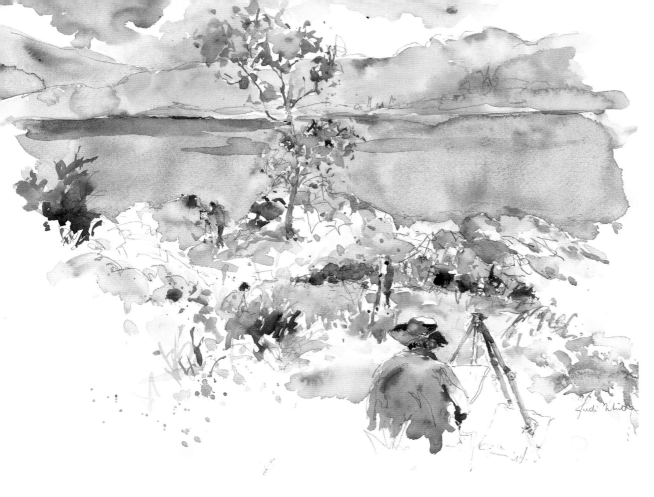

◁ Achintraid, West Highlands
30.5 × 45 cm (12 × 18 in)

The bottom of this on-location painting is vignetted and small indications of grasses link the painted and unpainted parts. An escape is provided on the left-hand side, underneath the dark bush, to integrate the positive and negative areas.

Linking areas

A good vignette will comprise a well-designed arrangement of painted and unpainted areas. You could consider the painted parts as the positive shapes and the white paper as the negative shapes. Links need to be made between the two and these could be provided using escape routes or calligraphy or by softening edges.

An escape route is created when the negative area creeps into the positive area and provides a transition between the two. For this to happen you need to practise describing shapes which are not totally filled in with paint.

Another way of providing this linkage is to use calligraphic marks on the borders of the white shapes to indicate what is happening in the unpainted areas. For example, in a vignetted landscape a few isolated foreground grasses might be useful to show this. In the same way, where a wall comprises the edge of your painted part, a few brick shapes can link the two areas.

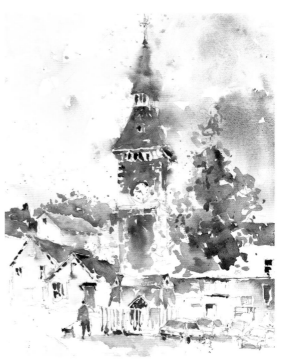

▷ Town Clock, Hay on Wye
29 × 20 cm (11½ × 7¾ in)

In this on-location painting an escape route has been provided just below the clock on the tower to link the painted structure with the unpainted sky shape.

A third way to provide links is to soften the painted edges – and indeed that is many people's conception of a vignette. I once asked a painter friend what the word 'vignette' meant to him and he described a painting which has detail and sharp focus in the centre and is softened and with less emphasis towards the edge.

I feel the soft edge and hard edge approaches are both equally valid. If you leave all hard edges this can sometimes look a bit abrupt and your vignette may have a 'cut out' look. At the other extreme, if your edges are all softened your watercolour can appear weak in design – and too little definition in a painting always looks as though the artist wasn't brave enough to make definite marks. Variety is the important issue and both defined and blurred edges can all be used together to enhance the final outcome.

◁ This subject includes several strong rectangular shapes. By presenting the painting as a vignette using linkages and softened edges some of the design issues can be resolved.

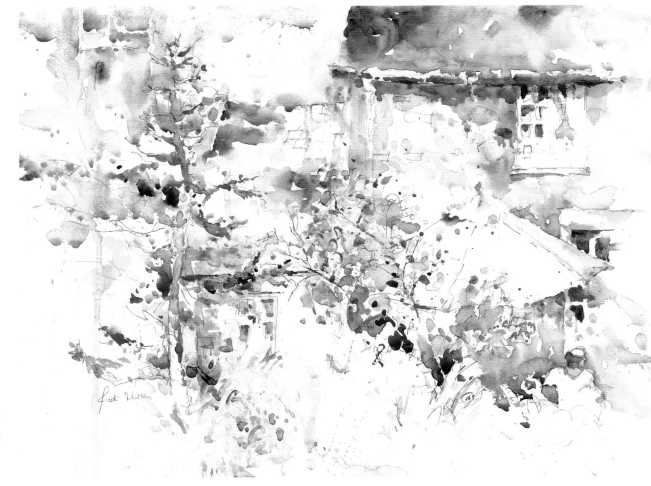

▷ Street Farm
35.5 × 51 cm (14 × 20 in)

This loose on-location painting illustrates how beneficial it is to have a variety of linkages between painted and unpainted areas. In the sky the painted edge is softened. In the wall of the house the linkage is made using weak washes and some isolated brick shapes.

DEMONSTRATION 2 Cap Ferrat, Provence

In this corner of Cap Ferrat the buildings harmonized in shades of ochres and pinks, marrying beautifully with the grey-green foliage. The bell tower provided a vertical element and the steps invited the viewer into the painting. I decided a vignette would enable me to concentrate on the central buildings and trees.
To give the sense of sunshine on the buildings I used the direct method in which the unpainted paper enhances the colours.

⊲ Stage one

Colours used

Naples Yellow
Cadmium Yellow
Raw Sienna
Cadmium Orange
(choose one that does not contain any 'yellow')
Coeruleum
Cobalt Blue
French Ultramarine
Prussian Blue
Burnt Umber
Burnt Sienna
Cadmium Red
Permanent Mauve

Stage one
I drew my subject as a vignette on a large sheet of Not paper on a block. The tower, harbour wall at the bottom and tree on the far left provided the directional pull towards the borders. The negative unpainted areas were designed to be interesting shapes. Using a No. 12 brush for the entire picture, I began painting parts of the tower using Raw Sienna, Naples Yellow, Cobalt Blue and Burnt Umber and leaving some of the drawn areas unpainted. The bottom of the tower was not linked to the buildings to provide an escape between the two sides of the picture. I added the sky using Cobalt Blue and splashed Coeruleum into the wet washes.

Stage two

I began a passage of painting in the heart of the picture. The buildings were painted using Raw Sienna, Naples Yellow and Cadmium Orange. I painted the adjoining trees using blues and yellows and allowed them to fuse into the building. My aim was always to hint and not overstate. I denoted the tree trunks and branches with Permanent Mauve, Raw Sienna and Burnt Umber. Further buildings and foliage were added as this passage of painting crept to the left. Finding I had unwittingly formed a distinctive large 'V' shape in the negative unpainted area between the tower and this central passage, I splashed paint to modify this and smudged the building roof.

◁ Stage two

Stage three

I painted the trees on the left-hand side and incorporated dark touches with Burnt Umber and Permanent Mauve. The paint was always applied wet-against-wet. Pure colours were taken from the palette, placed on the paper and allowed to mix with the adjoining colour. I added pigments by splashing. I constantly reminded myself to vary the hue and tone in the greens and take care of the overall shape of the trees. Further buildings were linked into the foliage. I took care to hint at the windows and avoid repeating shapes. Towards the edge I concentrated on how the painted area of the vignette would meet the border.

▷ Stage three

Stage four

I worked on the foreground buildings and the steps and hinted at the arches. I added some calligraphic marks, such as the railings, using my No. 12 brush. I deliberately used a large brush with a good point for these little lines as a small brush would not have given such a free mark. Splashes of Coeruleum and Cadmium Orange were applied for the harbour wall at the front. I teased these together slightly to define the flight of steps and took care where the painted area approached the picture border at the bottom. Bearing in mind my vignette design, I ensured this did not lie directly underneath the tower. Some pencil work was added at the end to complete the vignette.

▷ **Cap Ferrat, Provence**
35.5 × 43 cm (14 × 17 in)

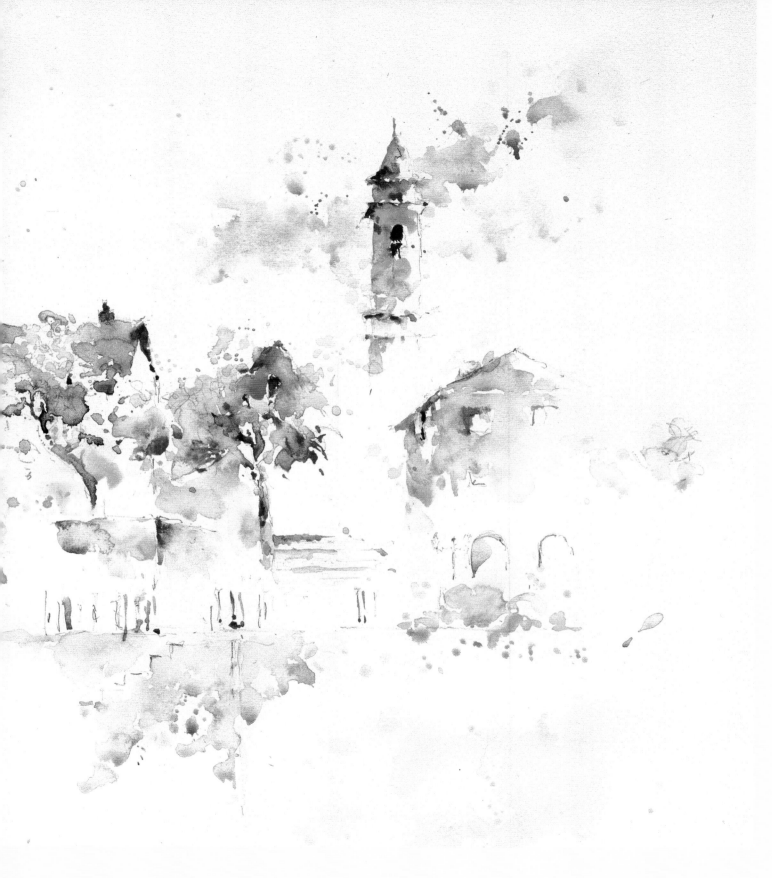

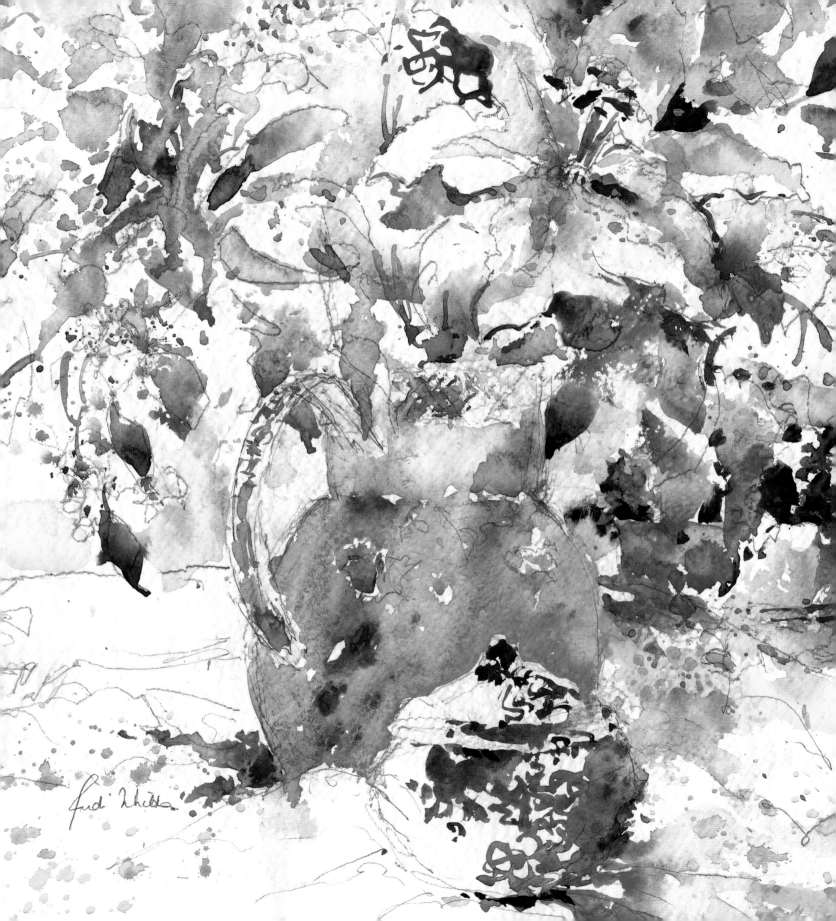

Planned spontaneity

Painting in watercolour naturally lends itself to producing lively work with a sense of spontaneity about it. For catching atmosphere with understated applications of paint, there is nothing to beat a loose watercolour painting.

I hope this book dispels the myth that to paint loosely in watercolour simply requires working quickly with plenty of water and pigment flying about. Producing a good loose painting often requires a very considered approach to the painting procedures.

This chapter investigates ways in which an air of spontaneity can be achieved in your work. They are not based on gimmicks but on a sound knowledge of watercolour techniques together with a close observation and understanding of the subject.

◁ Lilies and Ginger Jar
38 × 56 cm (15 × 22 in)

Understanding your subject

While you can certainly produce a free and lively watercolour in a very short period of time, a watercolour which looks spontaneous is often the result of meticulous planning and considerable care in execution. It is also an advantage to have plenty of experience in the handling of watercolour paints.

When you are watching a watercolour demonstration in a loose style, don't be fooled into thinking you can easily follow suit. The artist may appear to be rushing along without a care in the world, but he or she has probably had years of experience and knows the subject well. When it is your turn to paint you might be tempted to emulate the speed of application and find your painting turns out to look rather slapdash.

Time spent beforehand in considering your subject carefully will pay off in the finished result. Most of the watercolours I paint take quite some time to achieve, with thinking rather than painting accounting for quite a lot of it.

◁ Flowers on a Bar
33 × 18 cm (13 × 7 in)

Sitting in the bar with friends gave me time to think through my approach and plan my 'spontaneous' painting of the high bar. Including the stapler and the pile of saucers made the painting of the flowers more interesting. The stapler was painted with considerable care (see detail above), but the overall look of the work maintains a sense of immediacy.

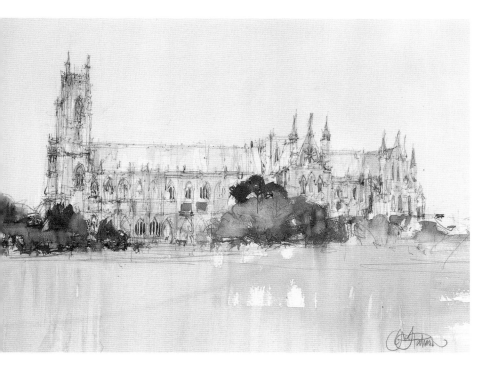

John Palmer
30.5 × 38 cm (12 × 15 in)

The lively and exciting use of the pencil marks gives this painting an amazing sense of spontaneity. Only a highly accomplished drawing ability can produce work with such freedom.

▽ Lilies
25.5 × 30.5 cm (10 × 12 in)

My intention was to show the lilies as they appeared in the flower border and in some sense imply their presence rather than make a feature of them. The pencil marks were an essential part of this plan and enabled liveliness and zest to be introduced into the form of the flowers.

Using lively pencil work

The marriage of watercolour paint and pencil or pen marks is fascinating. The watercolours of Paul Klee, Paul Signac and Raoul Dufy are inspiring examples of this way of working, as are the paintings of the British artist John Palmer where free pencil marks are combined with beautiful watercolour washes. Roland Hilder advocated the practice and development of the art of line drawing as a prelude to its becoming an integral part of the watercolour technique. He suggested artists should practise by drawing the things around them fearlessly and rapidly.

Lively pencil marks add to the sense of spontaneity. I usually begin the painting with pencil lines and then add some more during the progress of the painting. The pencil is an essential part of the finished work. You can draw with an HB, B or 2B pencil; a 3B or softer lead will smudge. I use an inexpensive disposable propelling pencil with an HB lead for all my drawing work.

It is important to remember that the paint does not merely fill in the pencil lines; they stand in their own right. Use stronger lines for emphasis or to bring parts of your subject forward.

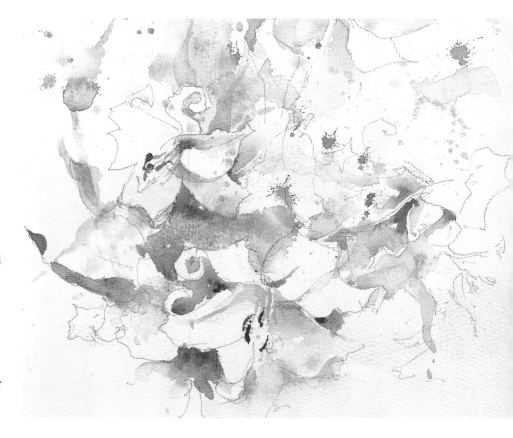

▷ Dancing Daisies
33 × 23 cm (13 × 9 in)

I controlled the background wash of Alizarin Crimson, Burnt Umber and French Ultramarine in order to leave unpainted flecks surrounding the daisy petals. This gave sparkle to the daisies and linked the flowers with the background. I designed the form of the missed areas by the direction of the brushstrokes.

▽ Clematis
26 × 30 cm (10½ × 11¾ in)

Put your finger over the small area of runs at the bottom of this watercolour to see whether you feel their absence lessens the overall vitality of the work. I think that without the dribbles it becomes a rather ordinary flower painting.

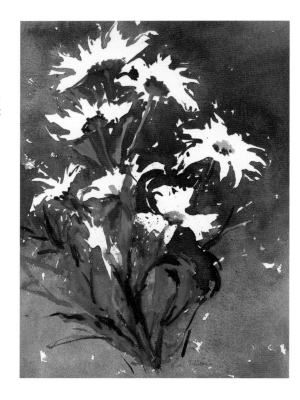

Retaining vitality

Scattered flecks of unpainted white paper can give sparkle and immediacy to a painting. If you feel your watercolour washes have become dull and uninteresting you can enliven the overall look of your work by leaving these small unpainted areas. Be cautious about being overgenerous with them, though, as leaving too many flecks can give a staccato, jumpy effect.

It is the direction of the brushstrokes that will give the flow to the white flecks that are left behind. Practise on scraps of watercolour paper with different surfaces, varying the amount of water in the brush, and you will soon learn to produce these missed areas of paint and control them to suggest a sense of movement.

Leaving runs

I belong to 'the messy watercolour school of painting' and am not too keen on a tidy finish. I like to work outside and become bound up with my painting. A side effect of this is that, without my realizing it, splashes and dribbles mysteriously appear on the paper. Worrying about these issues would detract from what I am trying to achieve, and I also feel that a finished watercolour with a few splashes and runs can have a vitality that is lacking in a neat studio piece.

It can be difficult at first to avoid the feeling that runs have spoilt your work, but you can train yourself to let them happen and capitalize on the resulting sense of immediacy in your finished watercolours. Be aware, though, that it is not advisable to leave many tonally strong runs as they might overpower your composition.

Studio tips

• Tidy up over-enthusiastic white flecks by filling them in while the first wash is still wet. If you wish to lose some of them later, fill them in at the end with a neutral wash.

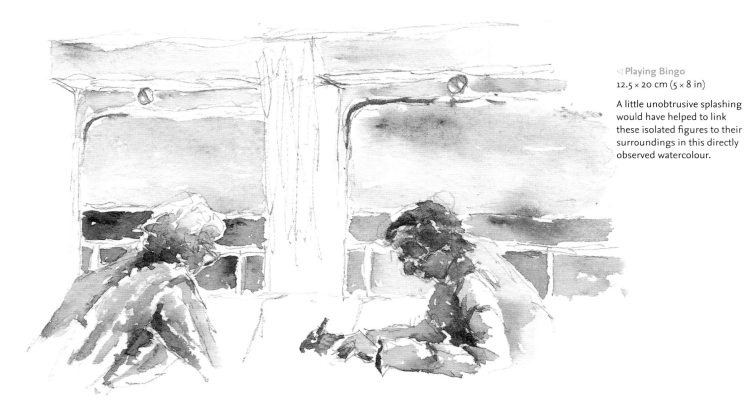

◁ Playing Bingo
12.5 × 20 cm (5 × 8 in)

A little unobtrusive splashing would have helped to link these isolated figures to their surroundings in this directly observed watercolour.

Splashing for spontaneity

Splashing the work was discussed on pp. 30–1 as a useful procedure to deliver pigment without the brush touching the paper. Splashes can also be used to give life and freedom to parts of the work which have become a little tight. If an area has become too detailed and stiff, splash on a light wash and the unpredictable outcome will help to free you up so that you can continue in a looser fashion.

Weak paint can also be splashed in the background to liven up your watercolour and to indicate a tie between the subject and the surroundings.

▷ The Stone Angel
33 × 25.5 cm (13 × 10 in)

Splashing is used in this on-location painting to link the statue to the background. Compare this with *Playing Bingo* above.

Liveliness in solid forms

It is all too easy to paint solid forms that appear flat and dead-looking, but the key to avoiding this is to use lively brushwork and to apply the paint in a dynamic way.

Using lively brushwork

If there is a large, solid form in your subject, such as a vase in a still life or a rooftop or strong shadow in a landscape, it is desirable to apply the paint in such a way that this shape does not dominate the completed work. It is quite important to link the elements to adjoining areas but you also need to control the application of paint carefully so that there is life and vitality in the observed form.

The example here shows how to give life to solid forms by the direct method, where the paint is placed on the paper in a lively fashion that is clearly evident in the finished result. It is quite important to link the elements to adjoining areas.

▷ Step 1

Using Cadmium Red and a touch of Burnt Umber, I placed patches of colour on to the roof with lively brushstrokes.

◁ Step 2

Cadmium Orange and Yellow Ochre were added in order to enable varying colours and tones to be incorporated.

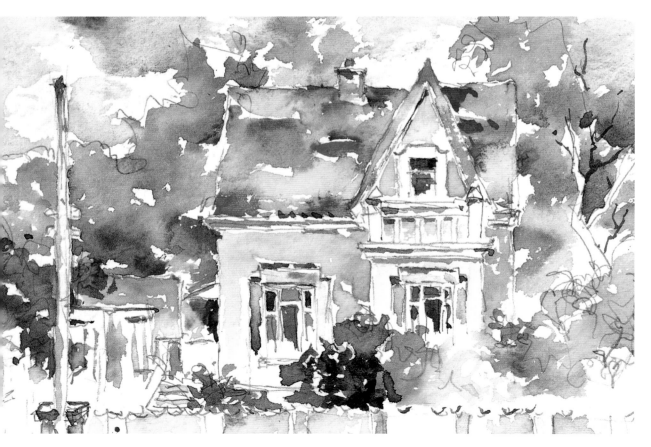

◁ Little House with Orange Roof
13 × 20 cm (5 × 8 in)

In this small painting there is the problem of a solid, regularly shaped roof viewed from the front. If this were painted as a strong, solid, flat shape it would be uninteresting and could dominate the watercolour. However, using several colours and lively brushstrokes and allowing the paint to mix on the paper gave it vitality and interest.

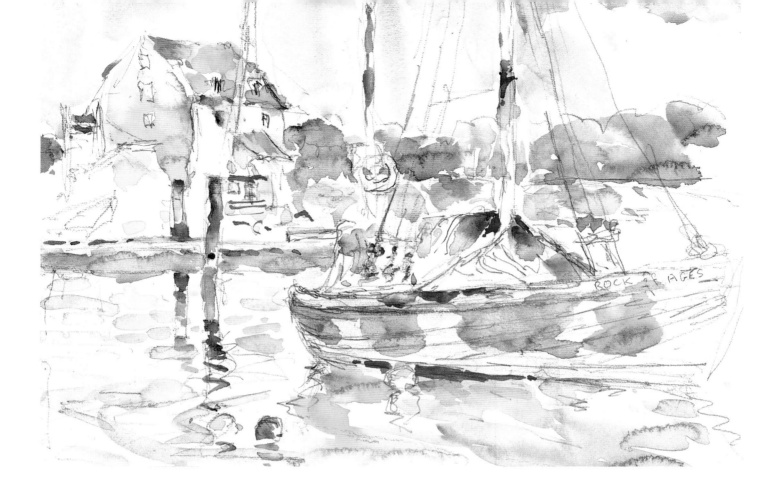

△ Woodbridge, Boat and
Tide Mill
30.5 × 46 cm (12 × 18 in)

To preserve a feeling of light
and spontaneity the solid
forms were not all filled in
with paint. After the initial
pencil drawing, patches of
local colour were placed
down within the boundaries.
The unpainted paper
surrounding these areas
enhanced the overall effect
of sunshine and colour.

Painting patches of colour

A very enjoyable challenge is to represent solid
forms by painting just a few patches of colour and
leaving much of the original shape unpainted. If
you have a drawing then the sense of what is going
on is clear to the viewer and the paint is simply
adding information. To what extent you decide to
fill in a particular shape with paint will depend on
the overall design of your picture. If, for example,
you have a carefully painted flower study the
addition of a solid blue vase may take attention away
from the flowers. If a touch of, say, Cobalt Blue in
the corner of the vase will convey what you have
observed then this will suffice.

The advantage of this approach is that it avoids
large, strong shapes of high colour intensity that
can dominate a painting and give an overall feeling
of brashness. It is a case that proves the old saying
'Less is more', for the reduced area of colour
surrounded by white paper gives light and
luminosity to the finished watercolour. The viewer
can easily establish what is going on in the picture
and fill in the missing areas.

Explore further

- Find some of your old paintings which you feel
 appear lifeless.
- On a scrap of paper, copy any solid, uninteresting
 shapes and repaint them using the techniques
 described above.
- When you have practised in this way, repaint your
 original work and try to maintain the zest and
 spirit of spontaneity.

DEMONSTRATION 3 Blue still life

This lovely still life just had to be painted. The naturalness of
the composition made it particularly appealing and there was no
feeling of 'arrangement' about the flowers. It is often easy to
regard the background of a still life as having secondary
importance but here the panelled door was perfect as a simple but
vital support to the overall composition. The subject was lit from
an artificial light source on one side and natural daylight on the
other. I selected the direct method for my painting.

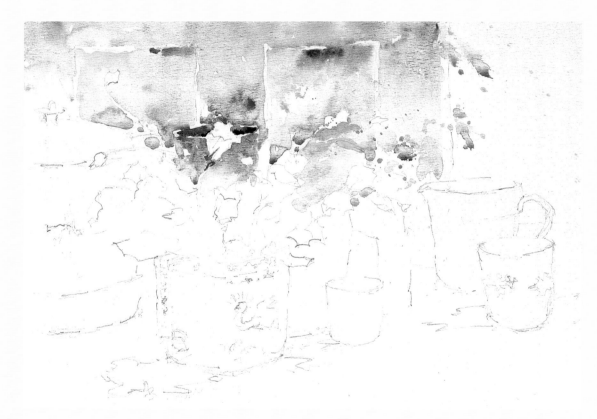

Colours used

Naples Yellow
Cadmium Yellow
Lemon Yellow
Raw Sienna
Cadmium Orange
(choose one that does not
contain any 'yellow')
Coeruleum
Cobalt Blue
French Ultramarine
Prussian Blue
Alizarin Crimson
Burnt Umber
Permanent Mauve
Phthalo Green

◁ Stage one

Stage one
I started the drawing on a large piece of Not paper,
leaving plenty of room at the bottom to allow space
for the shadows. I ensured the large vessel on the
left clipped the border while on the right there was
a breathing space. My eye level was slightly above the
taller pot and I took care to ensure the perspective
was consistent on the ellipses of the round vessel.

I began the painting process by splashing various
blues along with Cadmium Orange, Permanent
Mauve and Naples Yellow onto the background
door, using a No. 14 brush and lightly teasing the
paint together. I left small unpainted areas to
depict the door panels. Next I bled the central tall
vase into the door and portrayed the white flower
by negative painting.

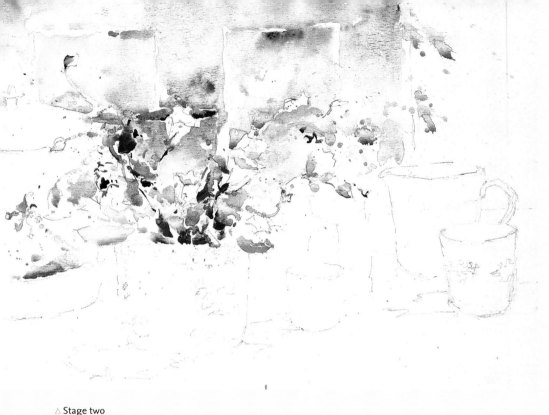

Stage two

The remainder of this passage of painting was completed using a No. 12 brush. I continued to work on the white flowers and foliage, taking enormous care not to surround all the petals with dark patches of paint as this would have resulted in a banal 'cut out' look. The white flowers were hinted at and the foliage painstakingly painted with a variety of blues and yellows and Phthalo Green placed on the paper. This passage of work continued to the large jar behind on the left. The shadowing on this jar ran into the cast shadow on the table using Coeruleum and Alizarin Crimson. Throughout the painting process I added further pencil marks which ultimately would be part of the finished watercolour.

Stage three

I began a new passage of painting on the right which involved the jug and patterned pot in front. These pots were predominantly blue and to redress the colour balance I used warm Cadmium Orange in the background area behind the jug. The shadows cast on the table were applied at the same time as the pots were painted. I added the patterning on the smaller pot towards the end of this passage, merely indicating a hint of pattern rather than trying to copy the observed pattern on the pot. This was partly to retain harmony in the painting style and also to avoid a detailed rendition of the pattern detracting from the more important design on the larger central mug.

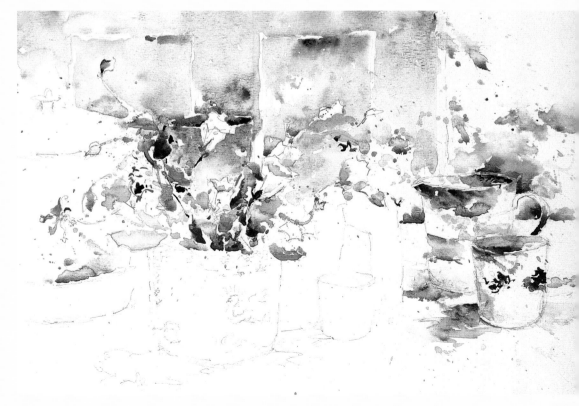

▷ Stage three

Stage four

Moving to the central area, I selected an element of the design on the forward mug and rendered it with Coeruleum and French Ultramarine. To draw attention to this pottery and suggest its roundness I used a bold application of Raw Sienna and Cadmium Orange down the front area and cooler purples and blues around the side. I continued by painting the handle and the shadows. At this stage it was necessary to design the cast shadows to pull the viewer into the picture and to balance any design problems. I constantly adjusted any static shapes which had been left in the unpainted paper. Finally, I checked over the painting to see if I had said enough, or too much.

▷ **Blue Still Life**
37 × 48 cm (14½ × 19 in)

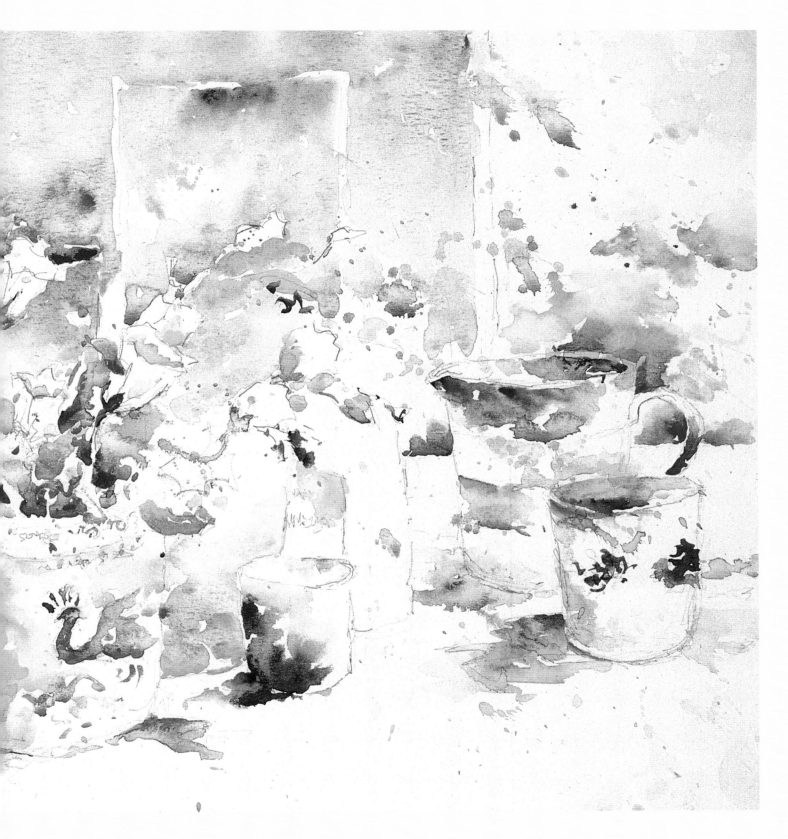

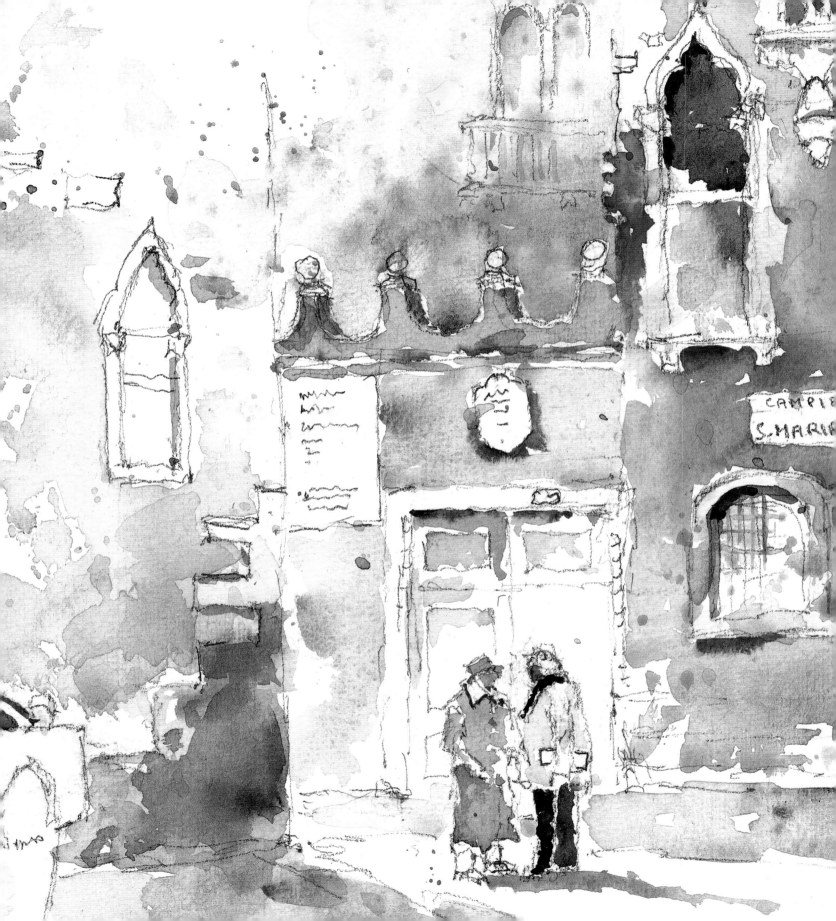

Painting outdoors

There is nothing like the excitement of capturing the atmospheric effects and facing up to the challenges which can arise from painting outdoors. Overcoming problems and battling with the weather can enliven your creativity and concentrate your mind, resulting in a lively and spontaneous painting that will have more meaning to you than a controlled studio piece.

Most of the paintings in this book were completed on location and this chapter, which is devoted to issues that beset all *plein air* painters, such as painting in the rain and the difficulties of changing light, is very close to my heart.

If it is difficult for you to go outside, do not be deterred – just paint what you are able to see through your windows or from your car.

◁ Sunny Corner, Venice
23 × 30 cm (9 × 12 in)

Using photographs

While it is always best to paint from life, it is sometimes necessary to use a photograph as a painting reference. Occasionally the camera provides you with opportunities you would not otherwise have, such as catching a fleeting moment, an animal, a person's gesture and an unexpected light effect. However, photographs do present problems you need to be aware of.

Losing the third dimension

When you are painting from a photograph rather than from life, you face the difficulty that you are already looking at a two-dimensional rather than three-dimensional object. So, when interpreting it in paint, you have lost all the opportunities to look properly at a three-dimensional object and use your skills as an artist to represent form as you can see it.

These skills are quickly lost if you persistently paint from photographs. Painting is not about copying things but about using your 'thinking vision' and then interpreting your feelings. Working from life enables you to produce honest and powerful watercolours which express your emotions and your love of the world around you.

△ The Lamb
23 × 20 cm (9 × 8 in)

From sketches of lambs done in the field I checked that the camera lens had not distorted my image too much. I rarely use photographs as painting reference but this lively subject would have been very difficult to paint from life.

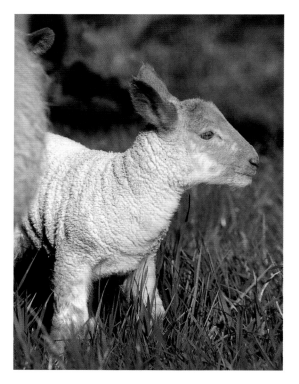

◁ This photograph was used as a reference for *The Lamb*, giving me more opportunity to study the animal's head (see detail, right).

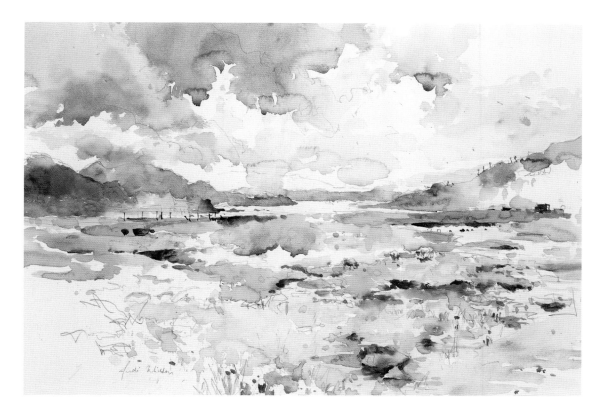

◁ Scottish Peat Bog
35.5 × 51 cm (14 × 20 in)

A comparison with the accompanying photograph shows how much more dramatic and exciting this landscape was in reality.

Distortion of the image

Be wary of distortion caused by the camera lens, particularly by wide-angle lenses, which make hills appear lower and distant buildings less pronounced. They also exaggerate the distance between objects (and conversely telephoto lenses will reduce it). By using a 'standard' lens of focal length 50 mm (for 35 mm film cameras) you are more likely to achieve a realistic image, but as the lens will not take in the expanse of landscape that your eye can see you may find it necessary to take several photographs in a panoramic style. If you have a digital camera you can take advantage of the fact that some lens distortions can be corrected using software.

I recall a student who had been out with me painting in a hilly landscape sadly redrawing her picture when she saw a photograph of the scene. The photograph, taken with a wide-angle lens, had distorted the view and had flattened out the image of the dramatic hillside. All the excitement was lost in the photograph and it rendered the drama of the scene into a banal and ordinary view of hills. If only she had had the confidence to trust her accurate on-location drawing.

◁ I took this photograph while I was completing my painting in the car. I used a wide-angled (40 mm) lens which distorted the image, flattening out the distance.

Explore further

- Do several quick sketches on location and take corresponding photographs. Note the settings on your camera and compare your drawings with the photographs.
- If you discover any marked difference between the two you will learn to correct any distortions when you are using photographic reference alone.

Painting in the rain

There is a beautiful soft quality to the light when it rains and, with a little organization, you can continue to work. Students on my courses are often dismayed when we set off in the rain for a day's painting, but using a little ingenuity to protect the paper results in plenty of pictures for the critique at the end of the day.

Without a tutor or a group to encourage you along it is easy to go home if it begins to rain, but if your spirits are flagging, think about the opportunities to paint the beautiful colours of wet pebbles or exciting townscapes with reflections on the pavements and umbrellas giving extra colour.

It may seem much easier to stay in the studio on a wet day and paint from photographic reference and sketches. However I often find that I become frustrated, as the reference material does not reveal the subtle colours and tones essential to a free watercolour interpretation. It is so much more worthwhile to gather together your materials and venture outside to paint from a sheltered place.

△ When rain starts I work in the shelter of my painting umbrella, which has a spike to stick in the ground.

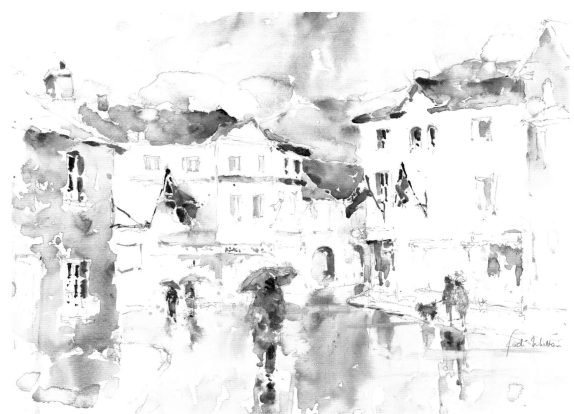

▷ Jubilee Flags, Crickhowell
28 × 38 cm (11 × 15 in)

This painting was completed from a parked car in the middle of the town. People scurried about under their umbrellas and provided exciting reflections in the wet pavements. I tried to make every part of the picture have the feeling of wet weather. Despite a bit of trouble from a misted-up windscreen we had a great time painting on a rainy day.

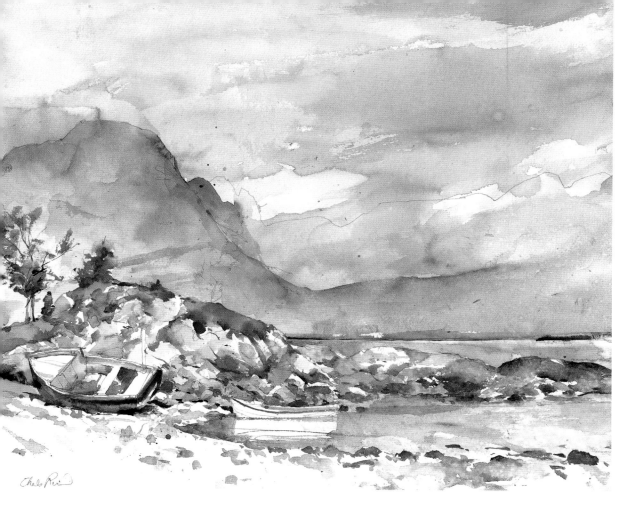

Charles Reid
38 × 48 cm (15 × 19 in)

This beautifully sensitive and harmonious watercolour painting was completed in the rain. Charles protected himself and the paper using a large fishing umbrella. The softly painted mist rolling in over the mountain makes a powerful statement and reflects the luminous quality of the light.

▽ Painting the Estuary in the Rain
25.5 × 41 cm (10 × 16 in)

There was no shelter and, having tipped the board away from the wind, I carried on painting despite a fine drizzle. Using very strong pigments enabled me to record some information about the landscape and my painting companions. The overall blurriness of the finished watercolour is a reflection of the conditions under which it was painted.

Practical points

It is usually possible to find shelter. Try painting in a doorway or under a lych gate, a market building or even a dense tree. Invest in a white painting umbrella, which can be erected in a trice if it begins to rain. Painting from the car is ideal in bad weather and just requires a little organization as to where you rest your paper and paints.

You cannot successfully paint in watercolour if rain is falling on the paper, so if you are unable to find shelter try to organize some polythene canopy to protect it. In a very light drizzle tip the paper away from the direction of the rain and work quickly, using very strong pigments to compensate for the wetness on the paper. If you cannot bear to get out the paints at all, take photographs from under your umbrella. You will be delighted with the soft, harmonious colours and tones.

Dampness in the air can hinder the drying process, so in wet weather it is better to paint using the direct method rather than the wash procedure.

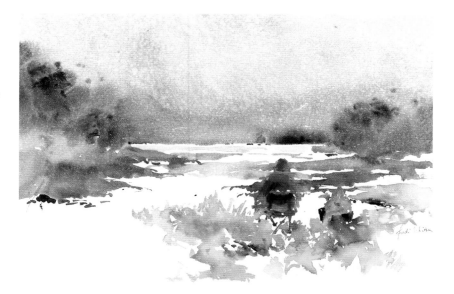

Changing light conditions

Changeable weather can be a problem when you are working outside as tones and colours alter while you paint. Imagine you are eagerly anticipating a happy day's painting on a summery beach. You settle down in bright sunshine and draw out your subject. Having evaluated the colours you begin to mix up a blue for the sky. You look up again and suddenly everything is different. The clouds have rolled in, the light has gone and the blue you have prepared is nowhere to be seen. How do you proceed now?

These problems have beset all *plein air* painters from Cotman and Turner to the present day. The solution lies in your preparation for any eventuality. Train yourself to note the important elements in the scene right from the start and to commit them to memory or jot them down in your sketchbook or along the borders of your paper support. It is a habit to develop and the more you paint outside the more adept you will become at foreseeing what to note.

◁ A sunny beach scene at Perranporth in Cornwall, with lovely light and shade on the rocks and a blue sky.

▷ Shortly afterwards the weather changed and the cliffs were now dark. Elements of the scene as it was in the previous photograph have now completely disappeared.

◁ Perranporth Beach 1
30.5 × 43 cm (12 × 17 in)

This *plein air* watercolour was completed on a very blowy sunlit day. As the clouds passed overhead the rock shadows were lost, so I made notes of the colours and shadow patterns on the border of the painting to help at these times.

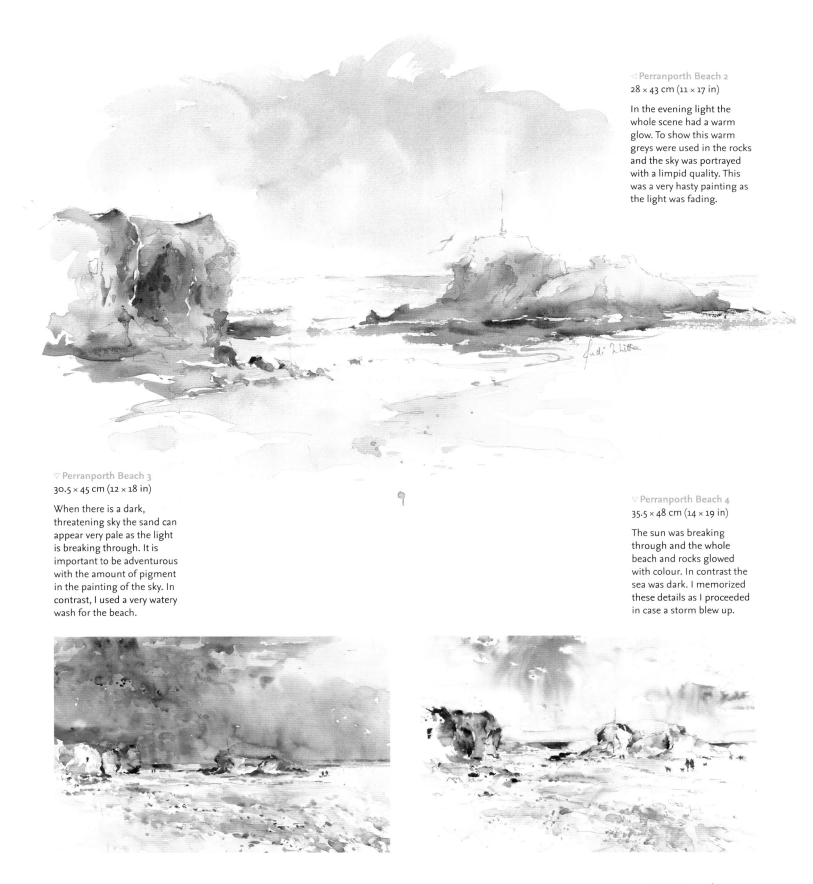

◁ Perranporth Beach 2
28 × 43 cm (11 × 17 in)

In the evening light the whole scene had a warm glow. To show this warm greys were used in the rocks and the sky was portrayed with a limpid quality. This was a very hasty painting as the light was fading.

▽ Perranporth Beach 3
30.5 × 45 cm (12 × 18 in)

When there is a dark, threatening sky the sand can appear very pale as the light is breaking through. It is important to be adventurous with the amount of pigment in the painting of the sky. In contrast, I used a very watery wash for the beach.

▽ Perranporth Beach 4
35.5 × 48 cm (14 × 19 in)

The sun was breaking through and the whole beach and rocks glowed with colour. In contrast the sea was dark. I memorized these details as I proceeded in case a storm blew up.

PROJECT Feeling the weather in your paintings

If you are lucky enough to be able to work outside you are halfway to expressing the feeling of the weather in your paintings. It is the interpretation of the atmosphere that lies at the very heart of watercolour paintings of the landscape.

If you are not able to be outside, the next best thing is to have sourced your own reference material, be it a sketch or a photograph, from as near to your chosen subject as possible. Being there, taking the photograph and having your memories of the occasion count for a lot.

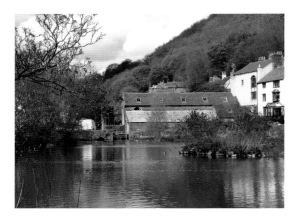

◁ Cromford Mill pond photographed in spring.

▽ **Cromford Mill Pond in Spring**
35 × 51 cm (14 × 20 in)

I painted this on site on a cold, bright day in April. The new foliage was sparse and had a yellow-green feeling to it. The buildings indicated pinks and blues to me – I did not see pink anywhere but it felt like the right colour to use with the blue-grey roofs.

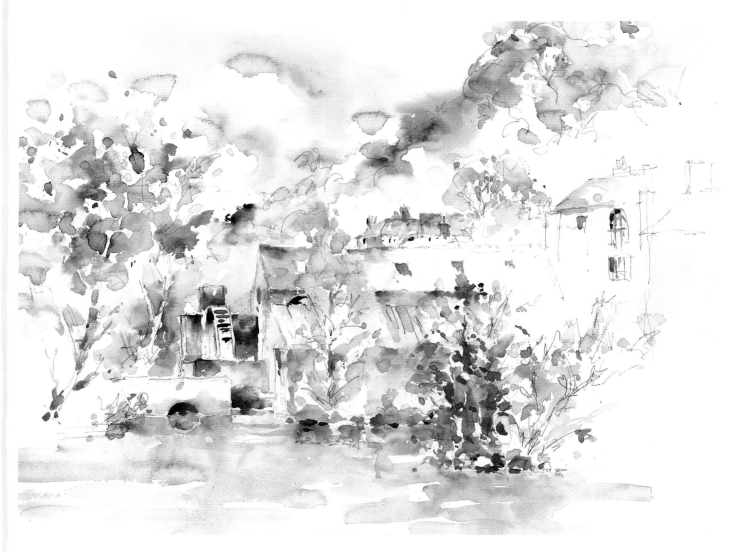

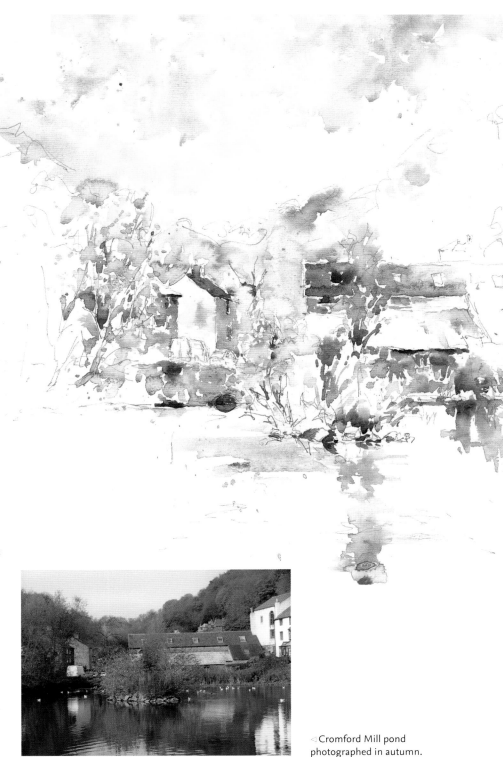

▷ Cromford Mill Pond
in Autumn
40 × 35.5 cm (16 × 14 in)

This painting was completed
on a calm, mellow October
day. I tried to capture the
harmonious sense of the
autumn tints and soft
golden greens. The painting
was designed as a portrait
format in order to include
the pronounced reflections.

Trust your emotions

Having chosen your subject, start by making
a drawing. Next, think about where to begin with
the painting. For this project, do not worry about
any of the technical rules of watercolour painting
but adapt any means at your disposal to capture
the feeling of the day.

Your selection of paints is quite crucial. Use
a limited palette of about six pigments and choose
them using your intuition about the scene in front
of you. This is easy to say and hard to do! Is there
a feeling of warmth or coolness in the air? Are there
any purplish hues noticeable? What about a sunlit
Naples Yellow area somewhere? Does the scene
make you think of orange? Is there a pink look about
it? Trust your intuition and your emotions about
your choices. You have to push the boat out here and
resist playing safe with colour.

Look at my paintings of Cromford Mill pond.
I selected different paints for the autumn and
spring paintings, and although I was not
particularly adventurous in my colour choices there
is a distinctly different feeling to the paintings.

It is hard to learn how to let emotions overtake
technical skills; it is much easier to learn techniques.
But we can all learn to exploit our emotional
reactions to a scene. Let yourself go – it is only a
piece of paper, after all!

◁ Cromford Mill pond
photographed in autumn.

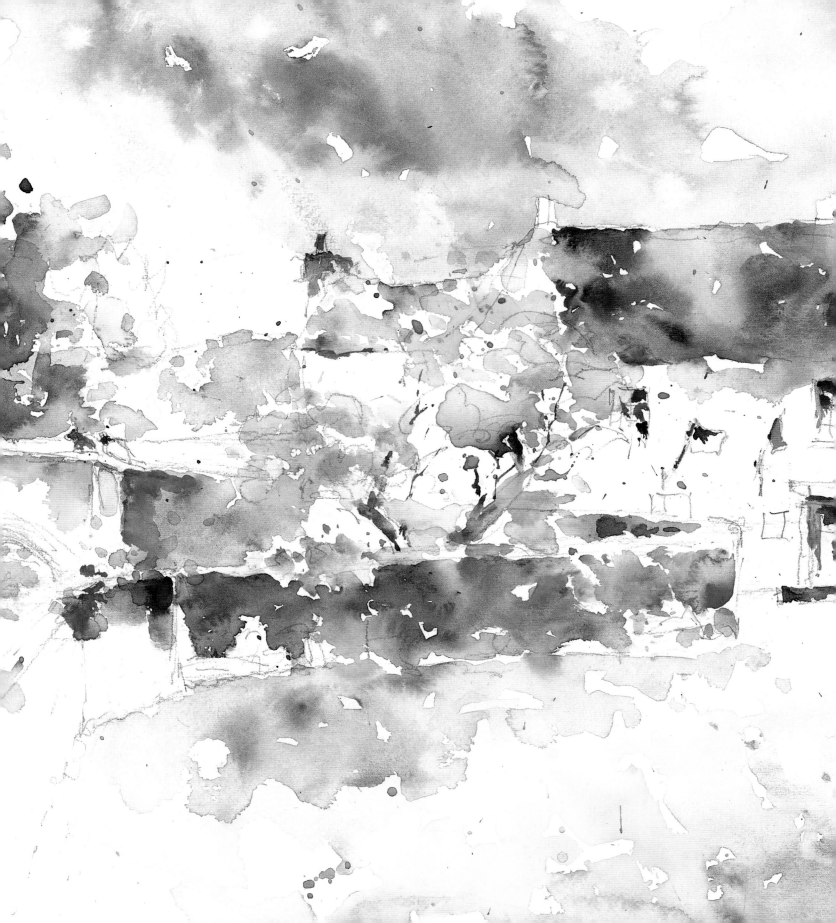

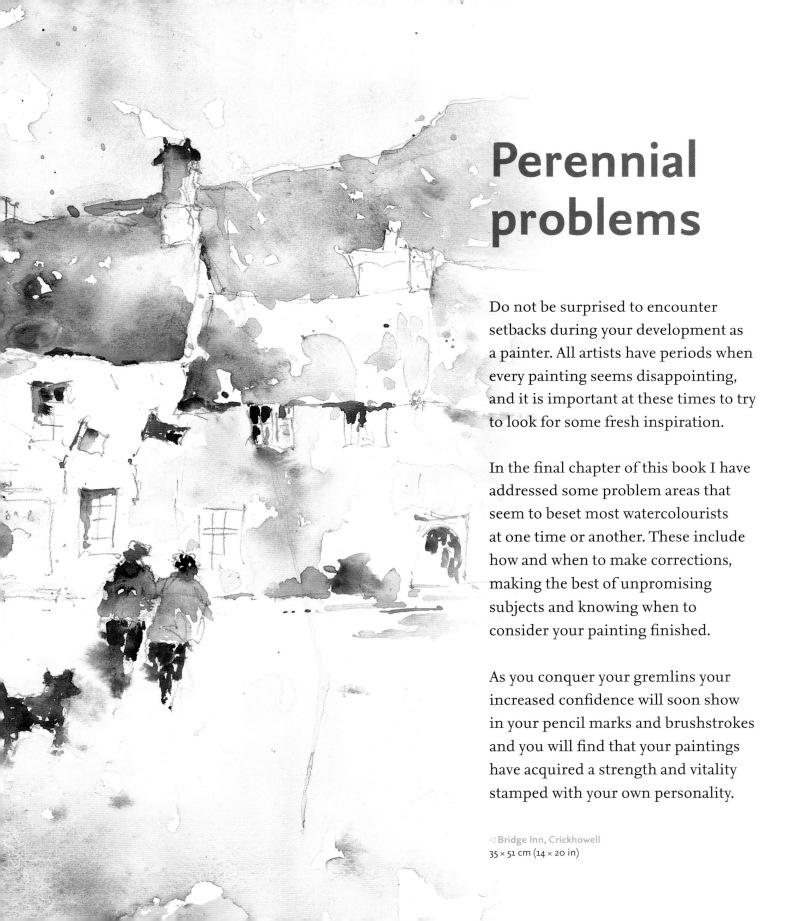

Perennial problems

Do not be surprised to encounter setbacks during your development as a painter. All artists have periods when every painting seems disappointing, and it is important at these times to try to look for some fresh inspiration.

In the final chapter of this book I have addressed some problem areas that seem to beset most watercolourists at one time or another. These include how and when to make corrections, making the best of unpromising subjects and knowing when to consider your painting finished.

As you conquer your gremlins your increased confidence will soon show in your pencil marks and brushstrokes and you will find that your paintings have acquired a strength and vitality stamped with your own personality.

◁ Bridge Inn, Crickhowell
35 × 51 cm (14 × 20 in)

Making corrections

It is best not to correct your work as you go along. Try to keep corrections to a minimum; if possible, build on events that you hadn't originally planned or decide that your mistake is not going to affect the overall result very much. Freshness and immediacy are important and the picture as a whole matters more than any individual part.

If you simply have to adjust some errors there are three main ways of doing this. Where the offending area is still wet, you can quickly dab off the paint with a tissue; if it has already dried you can carefully rewet the area with a brush and clean water and then lift off with a tissue. The success of this technique depends on the make of watercolour paper and the staining quality of the rogue paint. The third option is to overpaint the surface with white gouache and when it has dried repaint the corrected area with watercolour.

Painting with confidence

If you persistently correct your work as you paint, doubt creeps in and often it is downhill from then on. Painting is a psychological process and you need to keep encouraging yourself as you go along. If something doesn't go as you had hoped it is better to leave it alone, slightly readjust your plan and continue with strong conviction that it will turn out right in the end. It is important to feel buoyant as this will show in the marks you make. Look for any reason to boost your confidence during the painting process – doubt is the watercolourist's enemy.

△ **Steeple Ashton**
32 × 29 cm (12⅕ × 11⅕ in)

Paintings often dictate themselves to you and this was the case here. It is hard to analyse the painting procedure, but I was feeling my way along in this on-location watercolour when it became apparent that something was not right. I had painted the foliage down to meet the figures and I felt that this link did not work, so I used some white gouache over the offending area and retrieved the situation (see detail).

Studio tips

• Don't abandon paintings too soon – so much of promise may be lost and many pictures will be all right in the end.
• Don't hold a tissue in one hand while painting as this leads to a temptation to constantly dab out.

Painting on the move

During a journey you often have time on your hands and are also anchored to one place, so it is a golden opportunity to paint your environment. At first glance you may feel you have an awkward view, but prepare yourself with a compact painting kit and see what you can make of your surroundings and fellow passengers. Airports, train stations and harboursides provide a wealth of exciting subjects and travellers in a queue give you a chance to make some good sketches of people.

For your painting kit, a small journal with one No. 6 round brush, a small paintbox with pans of colour and two small plastic bottles will suffice. One bottle should have a wide neck so it can double as a paint pot; the other bottle is for discarded water.

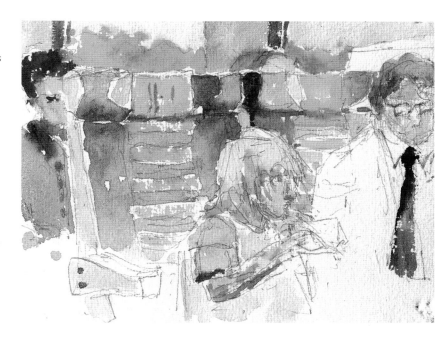

△ The Train Journey
12.5 × 18 cm (5 × 7 in)

This little girl fidgeted, but luckily the other people remained quite still. I painted everything except for the child and eventually managed to include her quickly when something caught her attention for a few minutes.

◁ The Coach Outing
15 × 30.5 cm (6 × 12 in)

Don't despair if you cannot see very much to paint. It was awkward to complete this little study because the coach was rocking but having seen its potential I found it great fun to do.

Explore further

- If you find yourself in a very unpromising situation with apparently nothing in view to paint, keep looking around you and try to extract anything of interest. Begin painting this selected item in the heart of your paper and try to design a picture by creeping out to the borders from this central point.

Coping with backgrounds

Backgrounds often present problems for painters. Outdoors, dark background areas can be too prominent and can overwhelm the main subject if not handled carefully; indoors, backgrounds in still life paintings, for example, need to be considered just as much as the objects themselves.

Dark banks of trees

Large banks of dark trees can be quite a problem when you are painting outdoors, as they can dominate the whole scene and are difficult to handle in watercolour. It is worth remembering that variety is the spice of life and the secret to achieving a successful background can frequently lie in introducing various colours and tones to relieve the denseness. Often any slight variety of colour or tone can be extracted and enhanced in a painting. Remember, too, that any strong dark edge to the trees will attract the eye of the viewer, especially if this edge lies against the sky.

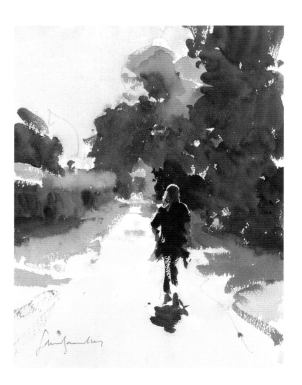

▷ Estelle with her Camera
John Yardley
33 × 25.5 cm (13 × 10 in)

In this lovely *contre-jour* watercolour the large bank of trees behind the figure has been painted with interest and restraint. Various colours and tones of green have been introduced and the edge of the bank of trees has been carefully handled.

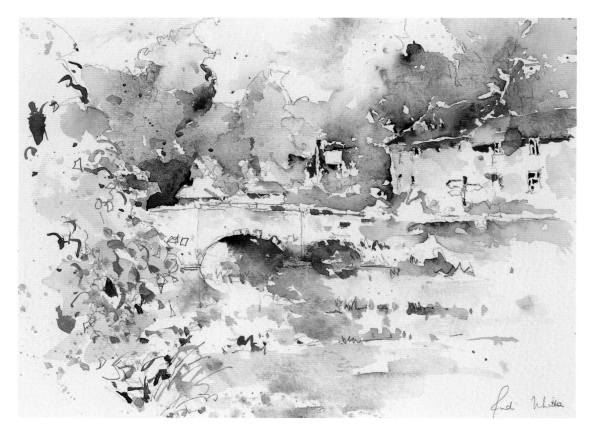

◁ Bibury, Cotswolds
25.5 × 30.5 cm (10 × 12 in)

A large area of trees lay across the entire background of this rural scene. In order to keep the light flooding into the central area, paler broken tones were used without compromising on the observed colours. Hints of purple and blue gave a feeling of depth.

15 × 20 cm (6 × 8 in)

I felt I had overworked this small painting. The paint handling is quite loose but there are too many fussy brushstrokes and too much information is shown, leaving the viewer's imagination very little to add.

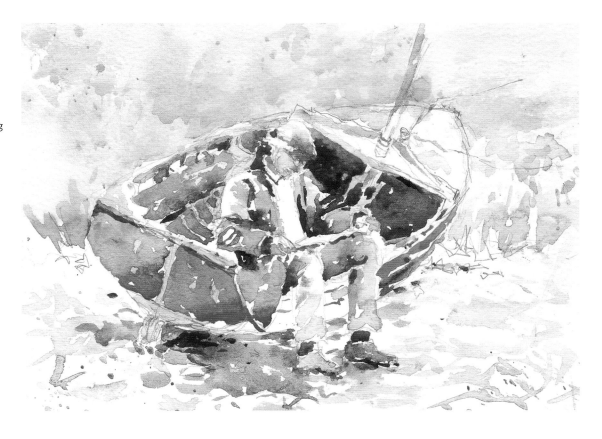

△ Fergal
13 × 17 cm (5 × 6 ½ in)

I thought of adding more shading on the body but where would it stop? Later I was glad I had halted.

When to finish

As you approach the end of your watercolour painting, you may find yourself in a dilemma about when to call a halt. There is often a temptation at this stage to add further detail and suddenly a fresh and spontaneous piece of work can rapidly go downhill and become fussy and overworked. It is a very delicate balance to decide when your picture is complete and many experienced professional painters fall into the trap of adding unnecessary information at the final stages to the detriment of the finished watercolour.

The degree of finish you choose is very subjective. If your painting is working compositionally and you are happy with your colours and tones, then your picture is finished when you feel you have got your message across. In practice it is difficult to decide exactly when that moment has arrived. It is a good idea to stop painting when you think you may have nearly finished. Take a break and when you return you will make a better judgement.

Making the best of it

It is sometimes said that artists should not paint a picture unless the subject appeals to them. However, if you follow this precept you will considerably limit your choice of subjects, as well as failing to exercise your creative ability to make the best of the opportunities that are available all around you. Whatever your subject may be, you will so quickly become totally absorbed in trying to express your feelings that you will just focus on the challenge of making a good picture.

In fact, subjects that are immediately eye-catching and attractive do not always make for a good painting; it becomes too easy to fall into the trap of producing a cute and commercial picture that is ultimately shallow. Never feel that you lack anything to paint, for the most ordinary objects can become intriguing when you look at them with your artist's eye, assessing tone, colour and composition rather than their everyday appeal, or absence of it. Keep painting, keep loose and you will find the joy of exploring your creativity and skill.

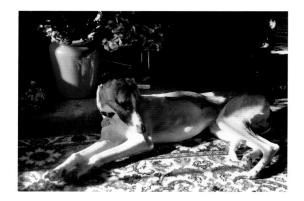

◁ My whippet Barnaby looks very paintable lying in the sun. Lucian Freud never made his whippet Pluto look cute in his paintings, but it is probably better to avoid painting from this photograph. The vase and flowers together with the dog's pose looks picturesque and a painting might appear contrived and done only for its commercial appeal.

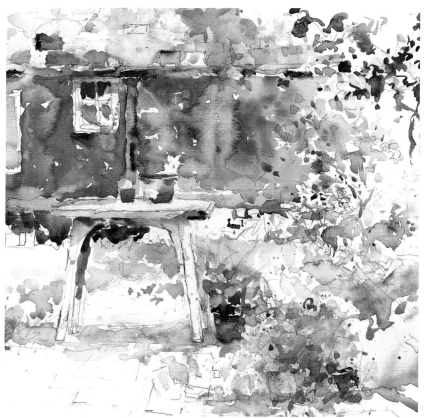

△ The White Plastic Table
24 × 24 cm (9 ½ × 9 ½ in)

While the subject was not as obviously attractive as my whippet, painting the legs on a white plastic table certainly filled the time while I was waiting for the rain to stop. As time rolled on this view became as pleasurable to paint as any other scene.

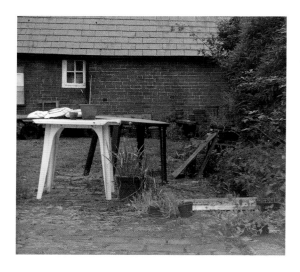

△ Having had to take shelter in a greenhouse, all I could see to paint was this aspect from the doorway.

Taking it further

There is a wealth of information available for artists, particularly if you have access to the internet. Here are some of the organizations or resources that you might find useful to help you to develop your painting.

ART MAGAZINES

The Artist, Caxton House, 63/65 High Street, Tenterden, Kent TN30 6BD; tel: 01580 763673
www.theartistmagazine.co.uk
Artists & Illustrators, The Fitzpatrick Building, 188-194 York Way, London N7 9QR; tel: 020 7700 8500
International Artist, P. O. Box 4316, Braintree, Essex CM7 4QZ; tel: 01371 811345
www.artinthemaking.com
Leisure Painter, Caxton House, 63/65 High Street, Tenterden, Kent TN30 6BD; tel: 01580 763315
www.leisurepainter.co.uk

ART MATERIALS

Daler-Rowney Ltd, Bracknell, Berkshire RG12 8ST; tel: 01344 424621
www.daler-rowney.com
T. N. Lawrence & Son Ltd, 208 Portland Road, Hove, West Sussex BN3 5QT; tel: 0845 644 3232 or 01273 260260
www.lawrence.co.uk
The Paintbox Company: suppliers of the handmade brass brush holder and the Sketcher's Box paint box; c/o Craig Young, 23 Friars Garden, Ludlow, Shropshire, SY8 1RX; tel: 01584 879848; email: craig.young123@ntlworld.com
Winsor & Newton, Whitefriars Avenue, Wealdstone, Harrow, Middlesex HA3 5RH; tel: 020 8427 4343
www.winsornewton.com

ART SHOWS

Artists & Illustrators Exhibition, The Fitzpatrick Building, 188-194 York Way, London N7 9QR; tel: 020 7700 8500 (for information and venue details)
Patchings Art, Craft & Design Festival, Patchings Art Centre, Patchings Farm, Oxton Road, Calverton, Nottinghamshire NG14 6NU; tel: 0115 965 3479
www.patchingsartcentre.co.uk

Affordable Art Fair, The Affordable Art Fair Ltd, Unit 3 Heathmans Road, London SW6 4TJ; tel: 020 7371 8787

ART SOCIETIES

Federation of British Artists (including Royal Society of Painters in Water Colours), Mall Galleries, 17 Carlton House Terrace, London SW1Y 5BD; tel: 020 7930 6844
www.mallgalleries.org.uk
Society for All Artists (SAA), P. O. Box 50, Newark, Nottinghamshire NG23 5GY; tel: 01949 844050
www.saa.co.uk

BOOKCLUBS FOR ARTISTS

Artists' Choice, P. O. Box 3, Huntingdon, Cambridgeshire PE28 0QX; tel: 01832 710201
www.artists-choice.co.uk
Painting for Pleasure, Brunel House, Newton Abbot, Devon TQ12 4BR; tel: 0870 44221223

INTERNET RESOURCES

Art Museum Network: the official website of the world's leading art museums
www.amn.org
Artcourses: an easy way to find part-time classes, workshops and painting holidays
www.artcourses.co.uk
The Arts Guild: on-line bookclub devoted to books on the art world
www.artsguild.co.uk
British Arts: useful resource with information about all art-related matters
www.britisharts.co.uk
British Library Net: comprehensive A-Z resource including 24-hour virtual museum/gallery
www.britishlibrary.net/museums.html
Galleryonthenet: provides member artists with gallery space on the internet
www.galleryonthenet.org.uk
Jackson's Art Supplies: on-line store and mail order company for art materials
www.jacksonsart.com
Judi Whitton: the author's website, with details of her courses, exhibitions and a gallery of her paintings
www.watercolour.co.uk

Open College of the Arts: an open-access college, offering home-study courses to students worldwide
www.oca-uk.com
Painters Online: interactive art club run by The Artist's Publishing Company
www.painters-online.com
WWW Virtual Library: extensive information on galleries worldwide
www.comlab.ox.ac.uk/archive/other/museums/galleries.html

VIDEOS

APV Films, 6 Alexandra Square, Chipping Norton, Oxfordshire OX7 5HL; tel: 01608 641798
www.apvfilms.com
Teaching Art, P. O. Box 50, Newark, Nottinghamshire NG23 5GY; tel: 01949 844050
www.teachingart.com

FURTHER READING

If you have enjoyed this book, why not have a look at other art instruction titles from Collins?

The Artist magazine, *The Artist's Watercolour Problem Solver*
Artists' Rescue Tactics
Bellamy, David, *Coastal Landscapes*
Gair, Angela, *Collins Artist's Manual*
Hodge, Susie, *How to Paint Like the Impressionists*
Jennings, Simon, *Collins Art Class*
Collins Artist's Colour Manual
Lidzey, John, *Watercolour in Close-up*
Shepherd, David, *Painting with David Shepherd*
Simmonds, Jackie, *Watercolour Innovations*
Soan, Hazel, *African Watercolours*
Stevens, Margaret, *The Art of Botanical Painting*
Trevena, Shirley, *Taking Risks with Watercolour*

For further information about Collins books visit our website:
www.collins.co.uk

Index

Page numbers in **bold** refer to captions

accent points 16, 71, **71**
adjacent colours **33**, 56, **56**
aerial perspective 78, **78**
anchoring vignettes 90-1, **90-1**
angles, boards and working surface
 26, **26**, **27**, **38**
atmosphere, conveying 29, 52, 105
attitude and philosophy 10, 12

backgrounds 48-9, **48-9**, 76, 79, **79**, 124, **124**
blacks 59, **59**
board angles 26, **26**, **27**, **38**
brushes **20**, 21, **21**
 brush-handling skills 14, 25, 27, **27**, **34**,
 102, 104, **104**
 wetness (pigment-to-water ratio) 26,
 27, 31, 44, 46, 102, 115, **115**

calligraphic marks 92, **96**, 101, **101**, 107
centres of interest **16**, 71, **71**
clothing 23, **23**
colour 54-7, **54-7**, 68
 blacks 59, **59**
 colourist painters 56, 68-9, **68-9**, 72
 darks 33, **33**
 greys **83**
 local colour 60, **61**, 81
 observing tone and colour 60-1, **60-1**,
 72, **72**, 105
 project 60-1, **60-1**
 whites 58, **58**
confidence 12, 16, 33, 79, 119, 122
contour drawing 39, **39**, 48, **48**, 60
cool and warm colours 54, **54**
corrections 122, **122**
creativity, developing 11
cut-out shapes **84**, **107**

dabbing off 122
darks 33, **33**
demonstrations 82-5, **82-5**, 94-7, **94-7**,
 106-9, **106-9**
design 63-81
 see also specific aspects (e.g., shapes)
details 13, **13**, 16, **16**
development and emphasis 78-9, **78-9**
direct method 45, **45**, 94-7, **94-7**, 104,
 104, 106-9, **106-9**, 115
drawing 38-9, **38-9**, 42, 48, **48**, 60, 101,
 101, 119
dribbles and runs 26, 102, **102**

edges, lost and found (soft and hard)
 42, **42**, 88, 92-3, **92-3**
editing and simplifying 15-16, **15**, 73, **73**,
 76-7, **76-7**, 78
emphasis and development 78-9, **78-9**
equipment and materials 19-23, 26, 43,
 101, 123
escapes 41, **41**, 49, 92, **92**, 94

families, colour 55, **55**
figures in landscapes 71, 74-5, **74-5**
finish 17, **17**, 91, **91**, 125, **125**
focal areas **16**, 71, **71**
forms, describing 28-9, **28-9**, 104-5, **104-5**

gouache overpainting 122, **122**
granulation 26
graphite lines 42, **43**
greys **83**

hard and soft edges 42, **42**, 88, 92-3, **92-3**

indoor working 22, **22**

keys, high and low 52

lead ins 70, **70**
lifting off 122
light
 indoor working 22, **22**
 outdoor working 116, **116-17**
line 64-5, **64-5**, 72, **72**, 101, **101**, 107
line and wash 42, 43, **43**, 65, 72
linking passages 16, 40, **40**, 41, **48**, 49,
 67, **103**, 104
 vignettes 91, **91**, 92-3, **92-3**
local colour 60, **61**, 81
location painting 23, **23**, 111-19, **111-19**,
 124, **124**
loosening up, approaches to 9-17

materials and equipment 19-23, 26, 43,
 101, 123
mixing pigments **26**, 27, **27**, 28-9, **28-9**,
 34-5, **34-5**, 46-7, **46-7**
mood, conveying 29, 52, 105
muddied work 32, **32**, 33, 44, **46**

notes and studies 34-5, **34-5**, 74-5, **74-5**,
 113, 116, **116**

observing tone and colour 60-1, **60-1**,
 72, **72**, 105
opacity, pigments 32, **32**, 44
outdoor working 23, **23**, 111-19, **111-19**,
 124, **124**
overfinishing 17, 125, **125**
overpainting 122, **122**
overworking 32, **32**, 33, 125, **125**

paint-handling skills
 developing 14, **14**, 34-5, **34-5**
 see also specific techniques (e.g.,
 wet-against-wet)
painting locations
 indoors 22, **22**
 journeys and travelling 123, **123**
 outdoors 23, **23**, 111-19, **111-19**, 124, **124**
painting loosely, approaches to 9-17
painting styles, tonal and colourist 56,
 68-9, **68-9**, 72
paints see pigments
palette
 layout 20
 mixing pigments on 28, **28**
Palmer, John 10, 42, **64**, 101, **101**
paper
 mixing pigments on 26, 27, **27**, 29,
 29, 33, **33**, 34-5, **34-5**, 46-7, **46-7**, 104
 selection 21
passages of working 40, 41
pathways (lead ins) 70, **70**
pen and wash 42, 43, **43**, 65, 72
perspective, aerial 78, **78**
philosophy and attitude 10, 12
photographs as reference **52**, 70, **73**, 80,
 81, 112-13, **112-13**, 114, 118, **118-19**
pigment transfer 25-35
 see also specific techniques (e.g.,
 wet-against-wet)
pigments
 colours in white subjects 58, **58**
 mixing **26**, 27, **27**, 28-9, **28-9**, 33, **33**,
 34-5, **34-5**, 46-7, **46-7**
 opacity and transparency 32, **32**, 44
 selection 20, **20**, 119
 tone 53
 wetness (pigment-to-water ratio) 26,
 27, 31, 44, 46, 102, 115, **115**
plein air painting 23, **23**, 111-19, **111-19**,
 124, **124**
problem-solving 121-6, **121-6**
projects 34-5, **34-5**, 48-9, **48-9**, 60-1,
 60-1, 74-5, **74-5**, 118-19, **118-19**

Reid, Charles 10, 12, 71, **72**, 76, **115**
runs and dribbles 26, 102, **102**

shadows 80-1, **80-1**, **107**, 108
shapes
 cut-out **84**, **107**
 describing forms 28-9, **28-9**, 104-5,
 104-5
 lost and found edges 42, **42**, 88, 92-3,
 92-3
 positive and negative 49, 66-7, **66-7**,
 88, 92, **93**
simplifying and editing 15-16, **15**, 73, **73**,
 76-7, **76-7**, 78

sketches and sketchbooks 21, 38-9, **38-9**,
 74-5, **74-5**, 113
soft and hard edges 42, **42**, 88, 92-3, **92-3**
solid forms 104-5, **104-5**
splashing 30-1, **30-1**, **95**, 96, 103, **103**, 106
splattering 30-1, **30-1**
spontaneity 12, **14**, 99-105, **99-105**
starting points 40
stopping painting, when to 17, **17**, 125, **125**
studies and notes 34-5, **34-5**, 74-5, **74-5**,
 113, 116, **116**
subjects
 changing emphasis 78-9, **78-9**
 integrating with background 48-9,
 48-9, 79, **79**
 intuitive reactions to 119
 simplifying and editing 15-16, **15**, 73,
 73, 76-7, **76-7**, 78
 understanding 14, 100
 unpromising 123, 126, **126**

temperature, colours 54, **54**
texture 30
thinking, ways of 10
tonal painters 56, 68, 72
tonal sketches 38, 52, **52**
tone 42, 50, 52-3, **52-3**, **67**, 72, **72**, 80-1, **80-1**
 project 60-1, **60-1**
translucency and transparency 32-3,
 32-3, 44, 46, **47**
travel and journeys 123, **123**

underpainting 44, **44**, 82-3, **82-3**
unpainted areas 56, **56**, 73, **73**, 83, 105, **105**
 flecks 102, **102**
 vignettes 87-97, **87-97**

vignettes 87-97, **87-97**

warm and cool colours 54, **54**
washes
 layering up 33
 line and wash 42, 43, **43**, 65, 72
 runs and dribbles 26, 102, **102**
 wash method 44, **44**, 82-5, **82-5**
weather 23, 114-17, **114-17**
 project 118-19, **118-19**
wet-against-wet technique 46-7, **46-7**,
 83, **95**
wet-into-wet technique 46-7, **46-7**
wetness (pigment-to-water ratio) 26, 27,
 31, 44, 46, 102, 115, **115**
white gouache overpainting 122, **122**
white paper 56, **56**, 73, **73**, 83, 105, **105**
 flecks 102, **102**
 vignettes 87-97, **87-97**
whites 58, **58**

Yardley, John **6**, 7, 10, 15, 76, **124**